Building Museums

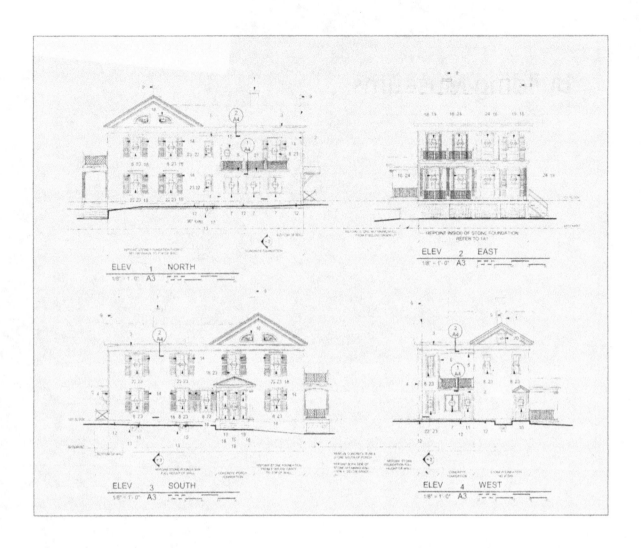

ELEV 1 NORTH
1/8" = 1'-0" A3

ELEV 2 EAST
1/8" = 1'-0" A3

ELEV 3 SOUTH
1/8" = 1'-0" A3

ELEV 4 WEST
1/8" = 1'-0" A3

BUILDING MUSEUMS

A Handbook for Small and Midsize Organizations

Robert Herskovitz, Timothy Glines, and David Grabitske

Minnesota Historical
Society Press

www.mhspress.org
The Minnesota Historical Society Press is
a member of the Association of American
University Presses.
Manufactured in the United States of America

10 9 8 7 6 5 4 3 2

♾ The paper used in this publication meets the
minimum requirements of the American National
Standard for Information Sciences—Permanence
for Printed Library Materials, ANSI Z39.48-1984.

International Standard Book Number
ISBN: 978-0-87351-847-5 (paper)
ISBN: 978-0-87351-856-7 (e-book)

Library of Congress Cataloging-in-Publication Data

Herskovitz, Robert.
 Building museums : a handbook for small
and midsize organizations / Robert Herskovitz,
Timothy Glines, and David Grabitske.
 p. cm.
 Includes bibliographical references and index.
 ISBN 978-0-87351-847-5 (pbk. : alk. paper)
 ISBN 978-0-87351-856-7 (e-book)
 1. Museum architecture—History—21st century.
2. Museum buildings—Designs and plans.
3. Interior architecture—Designs and plans.
I. Glines, Timothy. II. Grabitske, David. III. Title.
IV. Title: Handbook for small and midsize
organizations.
NA6690.H47 2012
069'.22—dc23

 2011036057

The text of this book is set in Chaparral Pro, a typeface
designed by Carol Twombly in 2000.
Book design by Wendy Holdman.

Contents

Acknowledgments

This book is dedicated to the memory of Charles W. Nelson (1945–2007). Charlie was the longtime historical architect at the Minnesota Historical Society and the State Historic Preservation Office. He cared deeply for small and midsize historical organizations and took great pleasure in helping the people who operated them. He was a key team member when this project was first conceived, and his enthusiasm, creativity, and insight guided the authors throughout.

Many people assisted in the development of this project, beginning with participants in an early focus group with whom we consulted and responders to a survey sent to county and local historical societies in Minnesota. Britta Bloomberg, Deputy State Historic Preservation Officer, supported us throughout and patiently helped us bring it to completion. Mary Ann Nord undertook an initial edit that helped us focus on the manuscript's structural issues. Gretchen Bratvold was our developmental editor; her perceptive questions helped us better articulate sometimes complicated issues and made significant organizational contributions. Rebecca Thatcher Ellis, P.E., provided valuable suggestions and nuanced advice on HVAC systems. Richard Rummel read and made significant contributions to the section on lighting. Stevan Layne helped guide us on issues related to museum security. Jim Soukup, Rocon Inc., and Laura Resler of the Steele County Historical Society graciously allowed access to the construction site for photos of work in progress on the society's new building. Joe Hoover created graphics, Lizzie Ehrenhalt and Dan Cagley helped with one of the photographs, and Jean Moberg stepped in when we needed technical sections reformatted for the manuscript.

We also want to thank Pamela McClanahan, director of the MHS Press, and our editors Ann Regan and Shannon Pennefeather. Their careful and thoughtful guidance brought the project to completion. Of course, the authors alone are responsible for any shortcomings in the published version.

Important financial support was provided by the Frank and Jean Chesley Fund for Local and County Historical Societies at the Minnesota Historical Society and the George W. Nielson Fund.

Finally, we thank the many volunteers and staff working at Minnesota's numerous county and local historical organizations. Projects they planned and undertook over a period of many years were the foundation for what we have learned and tried to present in a way that we hope will benefit others.

Bob Herskovitz
Tim Glines
David Grabitske
August 2011

Building Museums

Introduction

This publication is intended as a guide for small and midsize historical organizations that undertake construction projects—new buildings and additions to existing buildings as well as renovations. It is meant to be used by organizations that are run entirely by volunteers as well as those that have paid staff.

The genesis of this book originates with the experience of its authors, staff and former staff of the Minnesota Historical Society. In 1974 the Arizona Historical Society hired Bob Herskovitz to be its first conservator, performing treatments but also providing preservation advice concerning storage and exhibit methodology, equipment, and materials. He started work the same week a new, architect-designed major addition to the building opened. It included a large exhibit space with a twenty-two-foot-tall, south-facing set of windows, which admitted a great deal of daylight into exhibit galleries, light that could potentially cause significant and irreversible damage to the collections. Over the next several years, Bob implemented modifications to the well-intentioned architectural elements and climate control systems so that the building would work for both visitor enjoyment and collections preservation. Bob came to the Minnesota Historical Society in 1987 as its first head of conservation. He was one of twelve staff on the planning team for the Minnesota History Center (which opened in 1992), offering conservation advice and design input. He subsequently provided similar counsel for several other new facilities constructed by the Minnesota Historical Society.

Over the years, Bob's experience with facilities also benefited numerous local historical organizations. His colleague, Charles W. Nelson, state historical architect from 1971 to 2004, was often tapped by organizations facing structural problems, while Bob tended to answer questions concerning the preservation of collections contained within those buildings.

Organizations also came to them and other staff of the State Historic Preservation Department, including Tim Glines and David Grabitske, to review plans for new museums or renovations to an existing structure. Tim and David visited and worked closely with the more than five hundred local history organizations throughout Minnesota. The problem, however, in reviewing these projects was that requests often came so late in the process that little could be done to improve plans without significant expense for redesign. One day in late 2001, the group decided to create a brief book on museum construction to help small

organizations achieve their vision and goals while also getting the most for their limited budgets.

There are many reasons your organization might undertake a construction project. Perhaps you wish to expand programs to better serve your community. Or perhaps you have simply run out of room to store your growing archives or artifact collection. If you are lucky, a generous donor has offered to give you an existing building or perhaps even undeveloped land. Whatever the case, there are many factors to consider as you move ahead.

The opportunity to construct a new facility does not come along often, so it is important to do everything very well in your once-in-a-lifetime project. Before you start, you need to know what issues to consider and what questions to ask. The following chapters will introduce you to the construction process, from needs assessment and project planning to design development, budgeting, construction, and, finally, settling into your new space. A complete chapter is devoted to the particular needs of a museum, library, or archives in order to preserve historical collections. An understanding of both the construction process in general and the special concerns of museums will help you achieve your goals.

To succeed, it does not matter if your organization has paid staff or is run entirely by volunteers. Nor is it necessary to have extensive experience with building projects, but it is important to be careful and thorough as you work with the consultants and building trades professionals that you hire to do the project. Remember, architects and contractors will win awards for grand public spaces and not for functional spaces like storage rooms. To be successful, you need to stay focused on what you need the facility to accomplish and not be talked out of critical functionality in favor of optional opulence. To stay focused means that you must become the expert on museum buildings. This book will help you do that.

Key terms are defined in the glossary (pages 163–67) and many are italicized within the text.

There are two important areas this book does not address in depth. One is how to raise the money for your project. The other is development of exhibits for your new or expanded museum. Both are large topics for which many other resources are available. See Further Reading for selected publications addressing these critical subjects.

Imagining Your Project

You have decided that a construction project is the right direction for your organization. You may or may not know whether that means building from scratch, adding on, or renovating an existing building. In any case, you need to engage in a project development process that will bring your construction goals into sharper focus. Forming a vision of your future needs is critical to the success of your project. Equally important is having continuity of leadership to ensure that you are able to remain true to that vision throughout the entire construction project.

Where do you begin? This chapter walks you through the earliest phase of your project, when it may still be just an idea in people's heads. You may have been discussing these ideas, but you have yet to develop any formal plans.

> ### Keys to Project Success
>
> - Develop a shared vision of future needs.
> - Maintain continuity of leadership.

Assembling a Building Committee

Your organization's governing body, or board of directors, is ultimately responsible for the project, and its members will need to make key decisions. The governing body is the "owner" of the project and may choose to take on the work of a building committee to lead the project. Very often, however, the board of directors chooses not to be involved in the day-to-day details and instead appoints a building committee to lead the process of developing the project.

Roles of the Building Committee

The building committee has important responsibilities planning and overseeing completion of the project. The committee assists the governing body in preparing a project timeline that identifies various phases of planning and fundraising. In this process, the committee often works closely with a design professional or architect. While the goals of the project will remain constant, the pathway to achieving them must be flexible enough to incorporate lessons learned along the way.

The building committee also has a major communication function. It must be in regular contact with the board of directors, architect, general contractor, and other stakeholders in the project. This includes frequent updates with the public at large.

Often, another role for the committee is record keeping. It is very important to thoroughly document your project, and the building committee can be given this task. In some projects documentation may be included among the duties given to an architect, general contractor, or construction manager, but if you do not delegate those tasks to hired professionals it needs to be done internally.

Exploring possibilities is another important function of the building committee. Early on, you can research firsthand by visiting several other historical organizations that have done construction or expansion projects. These visits should include every member of the building committee. They are excellent ways to learn about what worked best—and what did not work well—for a similar historical organization. The conversations that committee members have with people who have done projects will help guide the discussions the building committee has later as the project vision takes a more concrete shape.

Leadership and Decision Making

In spite of these important roles, the building committee does not make major decisions without approval from the governing board. The full board of directors or governing authority will review decisions and must approve all contracts for the project. Having a board and a building committee that function well is critical to the success of the project. All need to work together well.

If your organization is a nonprofit, the building committee should be chaired by a member of the board of directors who is familiar with construction projects and is willing to learn about the special issues involved in museum projects. This person must also be able to devote a large amount of time to the project. If your organization is a unit of government, an employee with experience in construction projects might chair the committee. Depending on the scale of the project and its timelines for completion, leading a building project can be a full-time job.

How much authority should the building committee and its chair be given? It will depend on the scope and complexity of the project and the comfort level of the governing board. It is important at the beginning to spell out policies that define the authority of the committee and the chair. By doing so, you can avoid problems that could occur later if board members were to feel that important

decisions were being made without involvement of the entire governing board. Conversely, detailed policies can also permit the building committee or its chair to make minor decisions in a timely manner without having to present them to the full board, which may not meet frequently.

Makeup of the Building Committee

The building committee should include representatives from the board of directors, management, and staff (volunteer or paid). Which staff should be part of the committee will depend on their functions within the organization. They might include curators, collections managers, conservators, building maintenance, and education staff. Make sure the committee includes people with expertise that will be necessary to ensure your project's success. It should include a mix of board, staff, and possibly community representatives. Represent all aspects of your institution's operation. Size of the committee will vary depending on the size of the organization, the scope of the project, and timelines. Essentially, you will need enough people to accomplish the work in front of you.

The committee members should be chosen for their willingness to participate in the process and for their ability to devote the necessary time to see the project through to completion. This is especially important when recruiting people from the community. The committee members should be willing to participate in fact-finding field trips to visit nearby museums where a similar design approach has been successful. Finally, the committee members should be competent to describe and present the project to the general public, to local agencies, and to potential sponsors.

Keys to a Successful Building Committee

Be sure your building committee has a representative for each of the following interests:

- Museum volunteers and paid staff
- Finance
- Collections management and preservation
- Exhibits and education
- Building construction
- Building maintenance

Building Committee Interview Questions

Some questions to ask candidates for the building committee:

- What experience do you have with design or construction projects?
- What vision do you have for this project? What will a successful project look like to you?
- What time commitment are you able to make to see the project through to completion?
- What is your availability to participate in fact-finding trips to other museums in the region?
- What is your willingness to speak on behalf of this project to local agencies, potential sponsors, and the general public?

Assessing Your Needs

To plan a facility that will meet all your needs, your organization must know exactly what it wants to accomplish. You want to avoid mistakes, because they will be expensive to correct and your organization may have to live with the consequences for years. The best guarantee of a successful construction project is having all stakeholders agree on the goals of the project. A needs assessment will provide a solid foundation for your plan.

Who should be responsible for doing the needs assessment? It will depend on the time, interests, and talents available to your organization. In some cases it can be the entire governing board assisted by staff members. In other cases it might be a responsibility the board assigns to the building committee or to another temporary committee formed for this specific purpose.

In the assessment, be sure to address the needs of your facility: programs, services, visitors, the community, volunteers, and employees. You must also address the needs of the collections around which your programs and services are organized. None of this planning can be done in isolation; everything—staff, visitors, programs, services, collections—relates to everything else. The needs assessment has three steps:

1. Revisit what you do.
2. Study your audiences.
3. Assess your programs and services.

Revisit What You Do

What is it that you do? The first step in your needs assessment is to revisit the basic purpose of your organization—your mission. Most historical organizations have a very general mission statement—for example, to gather, preserve, and disseminate history. This is too general to be helpful for a needs assessment, so you will need to get more specific. You can start by brainstorming ways in which the mission is carried out and exploring ways it can be enhanced. Now is the time to dream big.

In your brainstorming sessions, ask questions like the following to help you look at your current programs and services in a new light. Your responses will help you identify the strengths and weaknesses of your organization.

What services do you offer? Why are they important?
How do they relate to your mission?

Many historical organizations are tempted to offer a wide assortment of services, but this it is not always a realistic goal even if all of them fit into your mission. Financial and human resources limit what can be achieved. People in the community might desire a particular service, but your organization might not be able to provide it because you lack either the money or the expertise to do it well.

Organizations that limit the services they provide often do so after careful analysis. For example, a historical society might determine that it need not create a museum that duplicates what another nearby organization already does. Its governing board might instead decide to focus on a small research facility and offer public programs at existing community venues.

A planning process to help make these decisions might have the following elements:

- Analyze your organization's current and potential strengths and weaknesses.
- Analyze external threats and opportunities that affect the organization (such as the economy, demographic changes, cultural trends, and possible competition and partner opportunities).

This addition to a National Register–listed building respects and draws its inspiration from the original.

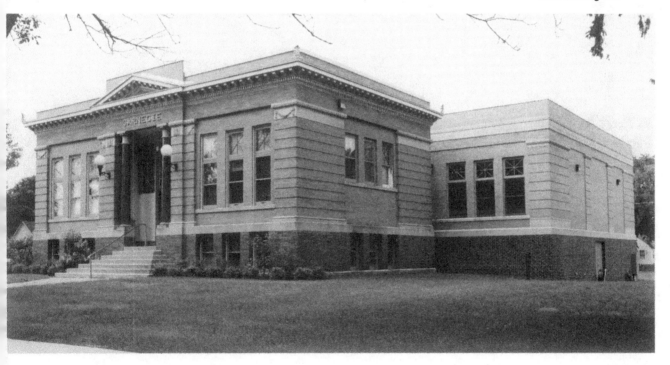

1. IMAGINING YOUR PROJECT

- Identify potential services and programs and learn about appropriate national standards in the museum field.
- Network with organizations similar to yours, particularly those with a reputation for high quality.
- Develop a detailed plan of action for each service or program you wish to provide and identify all the resources you will need.
- Determine how you will obtain the resources you need (see Feasibility Studies on page 15).

How might your facility be used by the community?

Historical organizations typically provide services such as research libraries, museums, and historic buildings or sites. But an organization's facilities might also serve other community needs. If your community lacks good meeting space for community gatherings, perhaps your new or remodeled building could include multipurpose rooms that other organizations could use.

This new museum takes its cues from the surrounding environment in its massing, profile, and selection of finish materials.

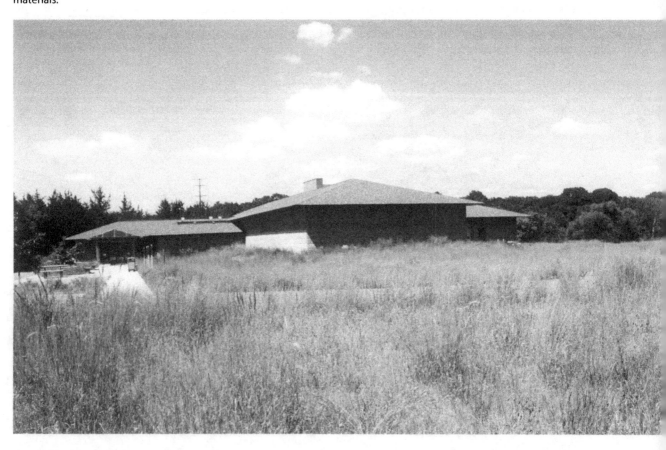

Matching Audiences with Programs and Services

PRIMARY AUDIENCE	PROGRAM OR SERVICE
Genealogists, family historians	Research library, lectures
Students grades 4–12	Exhibits, hands-on activities, classes, group tours
Seniors	Exhibits, lectures, talks, tours
Families with young children	Exhibits, hands-on activities
Young adults	Interactive exhibits
Historians	Research library, lectures, archives
Tourists	Exhibits, group tours, activities
Collectors	Research in collections, space to exhibit, lectures

What image do you want your building to project?

The appearance of a building communicates something about your organization and its role in the community. Some museum buildings, particularly those designed by well-known architects, make an artistic statement. Other designs seek to fit in with surrounding buildings or the natural environment. Your design should reflect your mission as an organization that preserves the community's cultural heritage. How the building does that depends on a variety of factors, including prevailing architectural styles in your community, the location of your building site, and, of course, your ability to pay for the project. In the case of an addition to an existing building, especially one listed in the National Register of Historic Places, the design should neither clash with the original structure nor mimic it so closely as to appear part of the original.

Study Your Audiences

In the second step of the needs assessment, learn as much as you can about the audiences you serve. This is a time to engage the broader community. Public meetings or focus groups can help you learn what the community values and wants from the organization. After looking broadly at the demographics of your community, focus more directly on your specific audiences.

For whom do you provide the services you offer? Identify the primary audiences for each of your programs and services. Making a visual chart can be a useful tool. Break down audience types as far as possible.

Then analyze how each audience engages with your organization. What is the nature of their contact with you?

- Do people come to view exhibits?
- Do they connect with you via technology, such as a website or computer stations in your research library?
- Do school groups visit your museum?
- Do visitors attend lectures, classes, or presentations?
- Do they purchase anything from you?
- Do they interact face to face with staff or volunteers?

Assess Your Programs and Services

Review each program and service you offer to determine its value to the community. In what way does each meet demand? Is it underutilized or overutilized? Describe. How could it be expanded or contracted? What would be gained or lost if the program were eliminated?

Exhibit Program

Exhibits are one of the ways that historical organizations serve the public. Exhibits use collections to convey information and ideas about the past. Historical organizations frequently undertake construction projects because current facilities are insufficient for the kinds of permanent and changing exhibits needed to successfully engage the community. Evaluate how well your current space meets your exhibit needs.

- Is the space large enough for what you wish to accomplish? If not, how much more is needed?
- Is the current space configured in a way that permits good exhibits? In what ways could it be improved?
- How does the current space support traffic flow and security? What could be improved?
- How well does the existing space provide an appropriate environment? Do unsuitable temperatures, humidity, and light levels threaten to shorten the life of your collections? What improvements are needed?

Library, Archival, and Research Services

Most historical organizations offer opportunities for genealogists, students, and other researchers to use the books, manuscripts, and records in the collections. Many organizations maintain good control over collections by storing

material in a separate room from which staff or volunteers retrieve it upon request. As collections grow, the space for storage and research may need to be expanded or altered.

- Do researchers have sufficient space to use the library and archival collections? How many more users do you anticipate in the future?
- How much additional space will you need to accommodate additional microfilm readers, printers, and computers?
- Does the space provide sufficient security while collections are being used? Would it be beneficial to have separate research and storage spaces?
- Does the space used by researchers have adequate temperature, humidity, and light control? In what ways might it be improved?

School and Other Educational Programs

Many organizations identify young people as a primary audience. Some hands-on programs for children can safely be conducted in exhibit spaces, but others might put collections at risk. The spaces for active, hands-on activities that engage children have special requirements.

- Do you have spaces for programs to use sinks, ovens, and stoves?
- Do you have a space that is used as a classroom?
- Is there storage space for tables, chairs, and other equipment?

Collections Storage

Almost all historical organizations and museums collect and preserve significant material, ranging from smaller items like books, diaries, and government records to large objects such as furniture, tractors, and even railroad engines. Inevitably, these collections will grow over time even if your organization has written policies that control and limit what you will accept.

Except when used by researchers or when on exhibit, the majority of objects and items in historical collections spend much of their time in secure storage. Expanding storage may even be a core reason for your construction project. Since your project is likely to be the only opportunity you will have to increase storage, be careful not to underestimate the amount of space needed both now and in the future.

- How many items do you own? How many are three-dimensional artifacts? How many are library or archival items? What is the volume of the space they currently occupy?
- Does a significant portion of the collection have poor accessibility because it is stored off-site?

Crowded and improper storage puts collections at risk for damage. Further, substandard storage casts the institution in a poor light for potential donors. This institution is currently conducting a capital campaign to build a new facility with state-of-the-art storage in addition to expanded work and exhibit spaces.

- At what rate do you anticipate the collections will grow? Will the growth be in a particular collection area? Are there areas of the collection that you want or need to increase?
- Do your collections need to be stored in a better environment (i.e., with temperature and humidity control) than you have now?
- Are security and fire protection adequate?

Do You Really Need More Space?

An important consideration at this point in the needs assessment is to step back and ask whether you really need additional space. Is it possible to reconfigure the space you have to meet your needs? For example, if your primary emphasis is genealogy research and you want more space for researchers and for archival and library storage, perhaps that space could be made available by reducing current exhibit space.

Often, the size of collections and anticipated growth push expansion projects. But this problem, too, can sometimes be solved without more space. Adding

compact storage systems, such as movable shelving units that ride on tracks, can be an answer that is less expensive than expansion. Another way to address the problem of the collections' size is to consider "deaccessioning" items that do not fit your organization's mission. Although deaccessioning must be done with forethought and care, it could mean that you would not need as much storage space as you initially thought.

Finally, additional overall space will almost always lead to increased annual operating costs for heating, cooling, lighting, and possibly more staff or volunteers.(For more on operating expenses, see pages 45–47.)

Determining Financial Capacity

While the building committee is engaged in all the components of imagining the project, a critical step is to determine if your organization will be able to raise the necessary funds. Without sufficient money, even the best-planned project cannot proceed.

Your organization may already have assets for a construction project. Is there an endowment or reserve available that would provide a significant portion of a capital campaign? Does the organization own land that could be sold to help pay for the project? Most organizations will need to raise significant funds as part of a capital campaign. This can be a challenge, particularly if your organization has not done anything like it before. So, how do you know whether you will be able to get the money you need? Will you need to consider doing your project in phases?

Feasibility Studies

To answer these questions, it may be necessary to conduct a financial feasibility study. Financial feasibility studies assess the probability that an organization can reach a specific goal in a capital campaign.

Although forecasting construction expenses is not the easiest thing to do, it is very important to have relatively accurate estimates of the costs of a building project, including exhibits, furnishings, interest charges for construction financing, and fundraising expenses. It is also important to have projections for any additional operating costs that will result from your project. Why is it important to have these estimates? They give a sense of confidence that your organization knows what it is doing, and they establish a sense of urgency about the need for a capital campaign.

In a feasibility study, potential donors and community leaders are interviewed confidentially with the goal of determining what the response will be to your campaign. Many organizations hire someone with experience in doing

financial feasibility studies. The advantage of using someone from outside your organization is that people who are being interviewed are more likely to be candid than if someone from your organization approached them. This is particularly important for those who may have doubts about your ability to complete the campaign. They might be unwilling to tell you directly but will be candid with a consultant, particularly when they know that their responses will be anonymous. (For help on finding consultants, see the sidebar on page 44.)

The results of the feasibility study will indicate how likely it is that your organization can raise the money it will need. If the study shows that you are unlikely to reach your goal within a reasonable amount of time, it may be necessary to postpone or scale back the project or to do it in phases in order to raise the needed funds over a longer period of time. Starting a capital campaign and failing to reach the goal could have a long-term negative effect on an organization's reputation.

Loans

Many organizations involved in facilities projects find it necessary at some point during the project to obtain a construction loan. This may be because some pledges for the capital campaign are not due for several years and cash is needed to pay for contractors and architects. If this is your case, you will need to be reasonably certain that the pledges made in the capital campaign will be honored. You do not want to borrow money for construction without knowing where the resources to repay the loan will come from. Organizations that borrow a significant percentage of the cost of a construction project can be severely hampered by having to include loan repayment as part of annual operating expenses. If your organization plans to obtain a construction loan, this will significantly increase the total cost of the project because you will need to include the cost of interest in your budget.

Increased Operating Expenses

A final but very important reminder about financial needs is to plan for the increased annual operating costs that will result from the project. Even if your project includes energy-efficient heating, cooling, and lighting systems, these potential savings may well be offset by the new facility's larger size. Most expansion projects result in additional annual costs for employees, cleaning and maintenance, supplies, equipment repair, insurance, and, last but not least, energy. Your plans should include accurate estimates of these costs and realistic ways to pay them. (See pages 45–47 for more on operating expenses.)

Deciding Whether to Build New, Buy an Existing Structure, or Renovate Your Current Space

After your organization has completed a needs assessment, it is time to decide whether to expand or renovate the building you now occupy, to acquire and renovate another existing building, or to build a new building. Each option usually has advantages and disadvantages.

For example, it may be difficult or impossible to add onto the building you now occupy because there is no room on the site. Or the current building may be configured in such a way that the space in an addition will not function well. However, the current building or its location may hold significance for your organization. It may be a historical building or have important architectural design features that the community values. Or the building might be in a location that helps identify your organization.

Sometimes acquiring and renovating an existing building is a good option. Renovation can be less expensive than building new, although this is not always the case. This option should be studied carefully because an existing building might not be easily or cheaply adapted to a historical organization's needs. Another possible advantage of using an existing building might be its location. It may be in an area that is easier to get to than your current location, has better parking availability, or is near other attractions.

Another reason to consider an existing building is the desire to save and reuse a historic building. Many people now feel that the greenest building is re-utilization of an existing building. But the desire to preserve a historic building must be weighed against the functional limitations such buildings bring with them.

New construction offers the opportunity to meet all of your organization's needs. With careful foresight, it can be a way to provide facilities that will serve well into the future. New construction is also an opportunity to build something with a distinguished design, which will lend prestige to your organization. But there can be disadvantages, too. An obvious disadvantage is the expense. It will be costly to do it right.

Evaluating Location

Perhaps the most important criterion, regardless of whether you are renovating or building new, is location. Recognize that inexpensive land in a poor location will be an obstacle to visitation and selecting such a site may prove a bad bargain in the long run. This is why location can be even more important than the cost of the project. Location can ensure the future success of your organization.

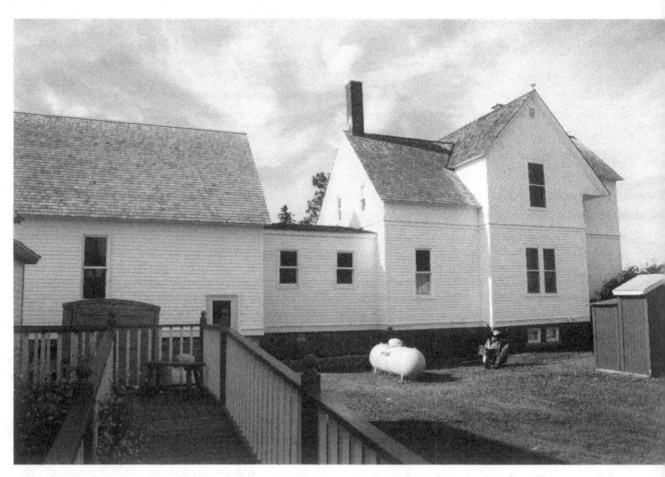

Sensitive additions are clearly differentiated from and sympathetic to the original building. Note the separation in roofline between the original on the right and the addition on the left.

Community Access

Consider whether the site is near other existing or planned attractions that people, especially tourists, might like to see or visit. Consult with local and regional planners to learn about improvement plans for streets, roads, recreational paths, and rail lines. Some questions to consider:

- Can visitors get to your building with relative ease?
- Will visitors feel safe and comfortable coming to the location at night?
- Is there space for adequate parking?
- Is the building on a public transportation route?
- Are there plans for new bus or rail routes or for walking, hiking, or bicycle trails that will attract visitors?

The Renovation Decision

If you are contemplating renovating a building to use as a museum, think about concerns like these:

- Status has responsibilities as well as privileges.

If the building is listed in the National Register of Historic Places, be aware that alterations or additions can have negative effects. Additions should be designed and constructed so that the character-defining features of the building are not radically changed, obscured, damaged, or destroyed in the process. Also, new design should always be clearly differentiated so that the addition does not appear to be part of the historic resource. (For more information, see *The Secretary of the Interior's Standards for Rehabilitation*: http://www.nps.gov/history/hps/tps/tax/rhb/new01.htm.)

If not designed well, the renovation or addition could result in the building's removal from the National Register. Why should you care if a historic building in your custody were to be removed from the National Register? As a nonprofit organization or governmental entity, you should be a responsible steward. If you neglect that responsibility, your standing in the community can suffer.

- Reusing a building designed for another purpose is complicated.

Even if the building you are considering is not listed in the National Register, there may be other considerations about altering older buildings. The building you have in mind was not likely designed as a museum. Those originally built for another purpose may be difficult to reuse as a museum. Two examples are family residences and railroad depots, but there are many other building types that might pose similar problems. Room sizes may be smaller or larger than those you want. Ceiling heights may not be appropriate. You may need to make significant structural changes to get the physical layout you want. Can this be done at a reasonable cost while ensuring structural integrity?

- Controlling the environment can be difficult.

Many existing buildings were not designed or built for humidity control. Adding the necessary vapor barriers, hard-wired sensors (humidistats), and air handlers (which deliver and remove humidity) can be difficult without significantly affecting the historic fabric and aesthetics of a historic building, especially those heated by radiators. These modifications can also be expensive. What will the improvements cost to provide the appropriate temperature and humidity? What design and construction challenges do the modifications present?

- Accessibility can be a challenge.

How can the building be made physically accessible to people with disabilities without having a negative effect on its historically significant features? A number of issues may need to be addressed, ranging from the need for an elevator to the design of entries, public restrooms, and eating areas. Your architect should be familiar with the federal Americans with Disabilities Act, which governs your project. For more information, see http://www.ada.gov/2010ADAstandards_index.htm.

- Code compliance can be costly.

Give careful consideration to the kinds of alterations that will be required to bring the building up to modern codes. Depending on its age and what has already been done to upgrade architectural features and electrical and plumbing systems, expensive changes may be necessary. These costs need to be factored into the decision to renovate an existing building.

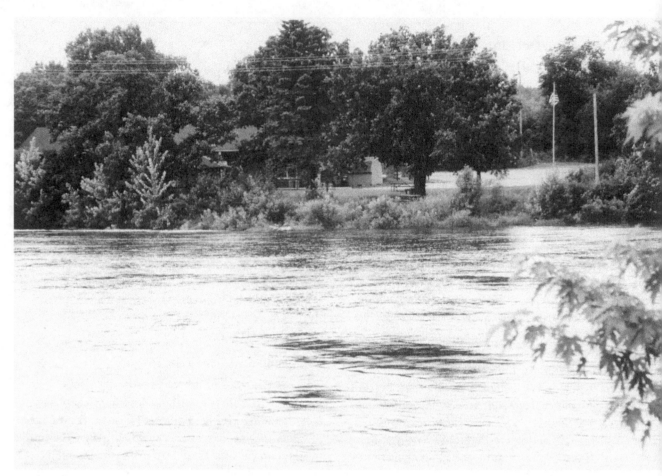

Site selection is important. Locating a museum in a floodplain is rarely a wise decision. The river is shown here at normal level.

Physical and Environmental Issues

Additional factors that will go into the important decision about locating your facility relate to physical and environmental issues. Some questions to ask:

- Is there space for future expansion?
- Is the location at or downwind of a source of significant air pollution, which might affect the air quality in the building?
- Is it close to a source of significant noise, such as an airport or active freight train line?
- Does the geology of the site require expensive site preparation due to bedrock, water, or soil conditions?
- Is the location susceptible to flooding?

Selecting a Designer

An important task of the board of directors (or governing authority) and the building committee is to choose a person or firm to provide the design expertise

essential to bringing your vision to reality. Because the number of museums that are built is low, relatively few architects have experience in museum design or renovation. They may not be familiar, for example, with the particulars and minutiae of exhibit galleries; of artifact and archival storage; and of museum heating, ventilation, and air conditioning (HVAC). A firm or an architect lacking museum experience will have a lot to learn and will be using your project as a learning experience.

Design-Build or Design-Bid-Build

Before getting started on selecting a designer, you should know about the two methods for designing and constructing buildings. They are similar, but they follow different processes.

One approach is to hire a general contractor or an architect working with a construction firm to both design and construct the building or addition. This is called *design-build*. The other approach is to hire an architect to do the design and prepare drawings and specifications that are then used to select a contractor through a bid process. This is called *design-bid-build*. Although a general contractor can usually manage designing a simple remodeling or upgrade project, few possess the technical expertise needed for a new museum or a significant addition to an existing one.

When to Begin Working with a Designer

Since most projects will benefit from the expertise of an architect, you will need to decide at what stage in the planning you will begin working with one. Some organizations resist retaining an architect at an early stage because the project budget is tight. Some board or building committee members may think that they can "manage" without an architect. Unless you happen to have an architect with museum design experience on your building committee, sorry to say, this approach is not good management of either time or money. A design professional leading your team will make it more likely that the building will achieve your goals and function according to your vision. The completion of the needs assessment is a good time to add the designer to your team.

Finding a Designer

How do you find the design professional that is right for your project? One way is to talk to people from other museums that have undertaken construction projects in the last five to eight years. Visit completed projects whose programs are similar to yours or to your aspirations. Find out how well the architect

worked with museum board and staff and how satisfied they were with the final product. Inquire if the project was completed on time and on budget. When you have identified architects who have good potential for your project, invite them to meet with you, preferably at your existing facility. In essence, this is an initial interview, so be prepared. In addition to listening to their presentation, have a set of questions that you will ask each candidate.

Once you have asked several people the same set of questions, their answers will allow you to compare "apples to apples." Be cautious and avoid high-pressure tactics or unrealistic promises. Your comfort level is important. You must be able to work with the person or firm you retain, and they must listen to and work with you.

Another way to select an architect is to hold a design competition. This method is used most often for large government projects. A written facility program (see page 24) often provides the parameters of the competition by laying out in detail the needs and requirements of the desired facility. The competition is advertised, and you may also invite firms to participate. The participants each submit a proposal, all of which are then evaluated by a committee. The committee will include museum staff and board, and you may also invite people with special expertise to assist, such as an independent architect or a professor of architecture from a local university. For those interested in more detail, the American Institute of Architects has published *The Handbook of Architectural Design Competitions*, which is available online at http://www.aia.org/aiaucmp/ groups/ek_members/documents/pdf/AIAP072762.pdf.

Questions for Prospective Designers

When exploring prospective designers, the American Institute of Architects (AIA) suggests asking the following questions (see also http://www.aia.org/value/yaya/AIAS076558):

- What does the architect see as the important issues to consider in the project?

- Evaluate the firm's style, personality, priorities, and approach: are they compatible with yours?

- What does the architect expect to contribute to the project?

- How much information does the architect need? How will he or she gather this information?

- How does the architect set priorities and make decisions?

- Who in the firm will work directly with you?

- How will engineering and other specialized design services be provided?

- How does the firm provide quality control during design?

- What is the firm's construction-cost experience?

Large Firms versus Small Firms

No simple formula exists to decide whether to hire a small or large firm, nor is there an inherent advantage to one or the other. When considering a large firm, base your decision not on the reputation of the firm but on the expertise and experience of the design architect and engineers who will actually work on your project. Do not assume that everyone who works in a large firm has the expertise and experience that you need. One advantage that large firms may offer is that their staff includes specialist experts—for example, an HVAC engineer—whose qualifications and experience you could evaluate before making a hiring decision.

Small firms may have the advantage of the designer being the principal on whose reputation the firm was built. When considering a small firm, be sure to ask who the firm usually hires for specialized expertise and whether those subcontractors have museum experience. Also ask how you would have input before consultants and subcontractors are hired. Always, regardless of the firm's size, you want to be included in the communication loop to ensure that the unique needs of your museum are met.

Staying True to Your Vision

By completing the imagining process, you have set the stage to start working on a design. You have determined the needs for the project based on a comprehensive set of specifications. You have matched the specifications with finances and selected a design professional. But amid all these details there are some basic principles to keep uppermost in your mind as you proceed with the design phase in chapter 2.

More than a century ago American architect Louis Sullivan wrote, "Form ever follows function." By this he meant that a building's use or function ought to determine its form. This is a useful idea to remember as your project progresses. Whether you are building new, adding on, or renovating, you must keep functionality foremost. The specifications you determine in chapter 1 and upon which you will elaborate in the next chapters tell your architect how you want the building to function. The project design phase often leads to creative tension between the "look" of the design and its functionality. Your job as the keeper of the vision is to see that form, or design, does not overwhelm and compromise the functional specifications you need to accomplish your mission.

How do you do this? One way is to use a facility program.

The Facility Program

The facility program is a document that serves as a major building block for any construction project, no matter how small. It includes detailed information to define and describe each of the spaces needed for the programs and services in the building. Although it is an optional step in the process, it is immensely worthwhile. The time and effort you put into preparing this document will pay you back in spades in the later phases of your project, because you will refer back to it again and again to keep the project's core values in clear focus.

During the design process, the facility program helps maintain balance in the "form versus function" equation, so that function is not sacrificed for form. At any point during design or construction, if cuts are necessary to keep the project on budget, the facility program serves as a guide to assess whether a proposed reduction will be acceptable. This is, after all, the goal: to design and construct a building that enables the institution to operate smoothly (i.e., function) and as envisioned while presenting a substantial and durable image (i.e., form) to the community.

〈〈 This is, after all, the goal: to design and construct a building that enables the institution to operate smoothly (i.e., function) . . . while presenting a substantial and durable image (i.e., form) to the community. 〉〉

Thus, the facility program provides not only a starting point for the architect but also a tool to use throughout the process. When done well, it is clear, specific, detailed, and comprehensive. It describes everything that you wish the building to be, to do, and to contain. It is a vital document that serves as the standard by which the building is measured as you progress through your construction project. In short, the facility program will help you stay true to your vision and avoid making decisions that you may regret after the project is completed.

At what point in the process should you do a facility program?

The timing can vary, but the first logical opportunity to create a facility program is once you have completed a needs assessment. This timing is highly advised particularly if you are planning to have a design competition to select an architect, so that you can use the facility program to clearly and consistently inform

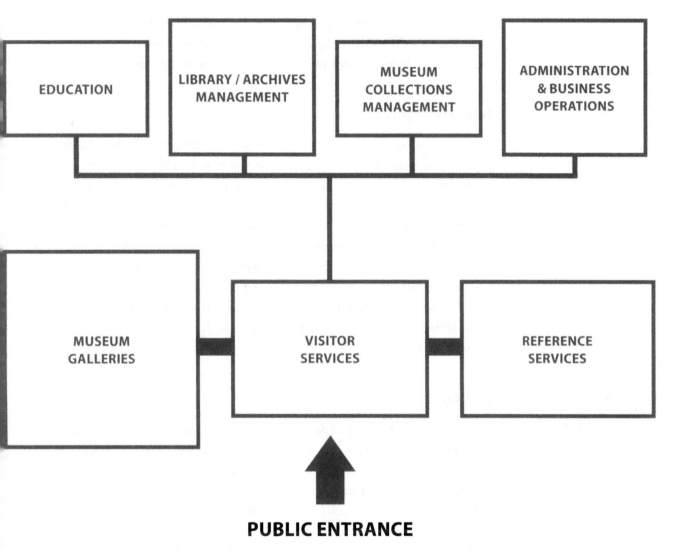

An example of an organizational flow chart, an element of a facility program.

all design participants about your project. Alternatively, the facility program can be done as part of the early stages of schematic design, the topic of chapter 2.

Who prepares the facility program?

The facility program will need the involvement of everyone within your organization, but depending on the scope of the project, you may want to hire someone to facilitate the process. Whom you hire will depend on when you do the facility program. If you do it before beginning schematic design, you may hire a consultant who specializes in preparing facility programs. (For help on finding consultants, see the sidebar on page 44.) This would be particularly useful if you

are planning to have a design competition. If, however, you have already selected an architect, or if you want to do the facility program as part of the early schematic phase, then your architect can help you prepare this document.

How is it prepared?

The facility program evolves from a series of meetings in which the architect or some other facilitator elicits thoughts, hopes, and ideas from the governing board, building committee, and museum volunteers and staff. The finished document provides a detailed written description of the building, including the spaces that it will contain, along with their functions, size, and relationships to each other (called *adjacencies*). It notes special needs or services required for various spaces and—very important for a museum—the environmental parameters for each space, especially noting the constraints for collections use and storage spaces that are required for the long-term preservation of the collections. In the case of an existing facility, the facility program helps inform how the site and the building itself can accommodate additional development.

The Next Steps

In the subsequent phases of design you will refine and further develop the project using a repetitive process that architects and designers often describe as "iterative." This simply means the act of repeating a process with the aim of moving closer to your result. Each repetition of the design process is referred to as an *iteration*, and the results of one iteration are used as the starting point for the next iteration.

Following the chapters on design you will find information about managing the construction phase of your project. But it is a good idea at this point to note that construction does not always go as planned. And when it does not go as planned and costs become an issue, there will be negotiations and inevitable compromises. Again, as the keeper of the vision you will need to remind your architect and your contractor of the specifications that are unique to museums and insist that necessary functionality is not sacrificed.

The Initial Plan Takes Shape— Schematic Design

The needs assessment outlined in chapter 1 gives you a general idea of what audiences you will serve, what programs and services you will provide for them, what your financial capacity is for construction, and whether you will renovate existing facilities or build new. With this assessment your architect can begin the actual design process.

The first phase of design is conceptual in nature. In a series of meetings with the building committee, your architect will organize more completely the concepts and requirements that you developed during the needs assessment. Architects refer to this first phase of design as *schematic design*. Once a scheme is agreed upon, the project moves into a more detailed phase of design called *design development*, which is covered in chapter 4. During schematic design, architects generally follow these steps:

1. Listing spatial requirements—the number and size of spaces within the building
2. Creating bubble diagram(s), a visual representation of relationships between spaces or functions (see page 39)
3. Preparing preliminary design sketches, or schematics, which will include three types of drawings:
 - A site plan, which shows how the building will be situated on the property
 - A floor plan for the interior of the building
 - Elevations, which show views of the building's exterior
4. Assembling an outline of specifications (lists of potential products and materials)

Depending on the complexity of your project, schematic drawings (generally referred to as *schematics*) may include a choice of two or three different options, or rough designs. Your architect will work with you to get a complete and accurate understanding of your project and to determine a design that will best meet your goals.

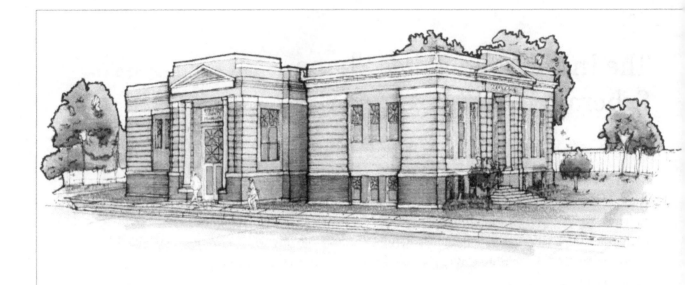

An artist rendering of your museum's design helps supporters and the community grasp the direction and desirability of your project.

This chapter focuses on the two steps in which your architect will seek the most input from you: listing spatial requirements and preparing preliminary drawings. The chapter also addresses preliminary budget checks, since by the end of the schematic phase you will have information that is concrete enough to gauge whether you have sufficient funds for your project.

Listing Spatial Requirements

Your architect will meet with you to identify the functions the facility will serve and how much space is required for each function. Use the following or similar questions to help prepare for these meetings. If you have not yet done a facility program, your answers to these questions can help you and your architect create one. (See page 24 for more on facility programs.)

We have broken out the questions into spatial categories. Depending on the size of your facility, you may want to combine several functions into fewer spaces, and you may not need all of the functions covered. Use these questions as a guide to the kinds of issues you should consider. As you go, identify each function as "public," "operations," or "mixed use." Doing so will help you determine functions that need to be adjacent to each other, the level of security for different areas, and how finished the space needs to be.

Key to Schematic Design Success

Make sure your architect understands the vision and specific functional requirements of your building. The more input you give, the closer the preliminary designs can get to addressing your needs.

Public Spaces

The public areas of your facility help visitors feel welcome. Public spaces affect one's overall experience and help determine the likelihood that visitors will come again and will recommend the museum to others.

Entrance(s)/Lobby

The museum's entrance creates the first impression that people have of your facility. You want to be sure this area will serve their needs.

- Will the entrance serve as a lobby or gathering place for tours?
- Will the entry area accommodate orientation activities?
- What other services—information desk, coat check, restrooms, museum shop, community meeting room—belong in or relate to the entrance?
- Will the public and staff share an entrance to the facility?
- Based on your answers to the preceding questions, how much space do you need?
- Do you plan or expect the lobby to also serve as an exhibit space? If so, then windows and outside light should be minimized so that light-sensitive artifacts can be displayed without risk of damage.

Information Desk

The staff at an information desk helps greet and orient visitors to your facility. You want visitors to be able to make the most of their visit and not miss anything of particular interest to them.

- How much space is needed?
- How will visitors find the information desk?
- Will the information function be combined with other duties, such as ticketing, sales, answering telephones, security? If so, how does that affect staffing, adjacencies, or other architectural elements?
- Will this desk also serve a security function? If so, how much additional space might be needed?

Museum Store

A store has the potential to be both a source of income and a publicity tool. The books and gifts that visitors purchase help extend awareness of the museum. Often the store is located so that visitors will pass by it before leaving the building.

- Will you have a museum store? If so, will it be combined with the information or reception space? How will it be staffed?
- Where will the store be located? How will the location relate to visitor flow patterns?
- What types of merchandise will be offered—books, brochures, souvenirs, gift items?
- How big a store do you need?
- How much storage space will be needed?

Coatroom

If your museum is open during cool or wet seasons, a coatroom provides a convenience for visitors. It also can offer a security measure for museums.

- Is a coatroom needed?
- Where should it be located? Near the entrance? The classroom or meeting room? The library?
- How much space is needed? Will it contain lockers or just coatracks?

Restrooms

In planning for restrooms, keep in mind that a convenient location is not the only consideration. Even more important is whether the location will force water pipes to run in or above collections use or storage spaces. You want to avoid any potential risk of water damage to your collections.

- What spaces should have close proximity to restrooms?
- How many and what size restrooms would accommodate projected visitor levels? (Your architect will have a formula for this.)
- Will restrooms be gender specific or unisex?
- Will staff share restrooms with the public or have separate facilities elsewhere in the building?

Food Service and Eating Area

Questions regarding if, when, and where food will be allowed in the museum are not simple and can have far-reaching consequences. School groups may bring lunches if extended visits and lessons are planned. Staff will want to bring food for lunches, snacks, and staff functions. Meetings and special events can be livelier when food is included. Yet there are risks to weigh carefully (see "Food in Museums," page 31).

- Will there be an eating area or will food and beverages be forbidden throughout the building?
- If the museum will offer food, how will it do so? Vending machines? Restaurant?
- If there is a restaurant, what route will food and supplies follow to the eating area, and how will waste be disposed?
- If there will be meetings and receptions with food served, where will they be held? What is the projected maximum capacity?
- Where will school groups go to eat bag lunches that they bring with them?
- Will there be a separate room for staff and volunteers to have lunch and take breaks?
- Will there be an outdoor picnic area?

Food in Museums

Whether or not to allow food in a museum can be a sticky subject. On one hand, there are advantages to being able to serve food at community meetings, receptions, and exhibit openings. There is also potential income if food is permitted at rental functions such as weddings or if food is sold to visitors. On the other hand, food in a museum poses two risks that can seriously damage collections: 1) infestations of insects and rodents, and 2) food and beverage spills.

While it is desirable to have visitors view exhibit galleries during events and parties, food and drink should never be allowed in galleries. Imagine a wedding dress that made it through its original use without a stain only to be soiled as a result of an accident during a museum event. If food is to be allowed in your museum, the building can be designed to discourage food and drink from entering the galleries. This is an important concern to discuss with your architect.

Parking Lot

Being able to park a vehicle and get to the building's entrance easily are important parts of a visitor's experience.

- Will the new or expanded facility need to plan for parking spaces?
- Estimate daily needs as well as traffic volume for events. For example, how many cars might be expected for meetings in the community room?
- Do local ordinances require you to provide off-street parking?
- Is your site large enough to accommodate parking spaces?
- Where will staff and volunteers park?
- Identify access routes from parking to the public entrance and to the delivery entrance. Are they convenient?

Programmatic Spaces

Programmatic spaces fulfill the heart of your organization's mission. They include public access to collections and to places for presentations and for interactive learning. Careful consideration of what you have in your collection and of what services you provide will help you maximize the use of programmatic spaces to the benefit of everyone who comes to your facility.

Library and Archives

Most historical organizations have or hope to have substantial collections of books, photographs, maps, business and government records, letters, diaries, and manuscripts that are made available to the public for research. The space to use these materials needs to be planned carefully, both for the convenience of researchers and in order to protect items that are irreplaceable.

- How much space is desired? How little space would be acceptable?
- How much space is desired for researchers and public use?
- What equipment will be provided for researchers and public use? Will there be computers? Microfilm readers?
- Will there be a staffed reference desk in the room?
- How will researchers have intellectual access to the collections? Card catalogs? Finding aids? Databases?
- How will researchers request material that is in secure storage?
- Will the archives storage be separate from the research area?
- What materials will be on open shelves and what will be in secure storage?
- Will the library be open at times when the exhibit gallery is closed? If so, will there be access and security issues?
- Will adjacent office space be provided for staff or volunteers?
- Is there easy access to restrooms?
- Will researchers be required to check coats and bags before entering the library?

Exhibit Gallery

Some of your exhibits might be relatively permanent, while others will change every several months or every year, possibly two. Because each exhibition may have a unique floor plan, your gallery space needs to be flexible to allow walls and lighting to be easily reconfigured. The objects in your exhibits also have stringent environmental requirements to ensure their preservation.

- How much exhibition space is desired? How little space would be acceptable?
- What types of exhibits will occupy the space?
- What light sensitivities do your artifacts have? Remember, daylight entering the gallery from windows will damage your collection. (See pages 87–96 for a discussion on lighting.)
- Does the building lend itself to exhibit space that is open and flexible, or will columns or other structural or architectural elements present constraints?
- How easy is it to get from the building entrance to the exhibit galleries?
- Will security be electronic (i.e., cameras), or will staff or volunteers be present and need line of sight? Or, a combination?
- Are restrooms and coatrooms nearby?
- Is there easy access for collections, including large objects, coming from storage or a preparation area?
- Where will you store unused manikins, exhibit cases, and other furniture?

Classroom

If in your needs assessment you identified educational programs as part of your organization's mission, then you need to plan where these programs will take place. Rather than a dedicated classroom, you might consider a multipurpose room.

- Will you have a separate classroom?
- If so, how big does it need to be?
- What other spaces should it be close to?
- Where will you have dedicated storage space for supplies and equipment?

Meeting or Community Room

A meeting or community room is a multipurpose space that might be used by other groups or organizations as well as for your own purposes. This space needs to be flexible to accommodate a variety of uses. It could, for example, also serve your educational programs and eliminate the need for a separate classroom.

- Do you want or need a meeting room?
- What functions will a meeting room serve?
- How many people should the room accommodate? What size meeting room is most in demand in your community?

- Will food be allowed in this space?
- If you plan to allow food in this space, where will food preparation or staging take place?
- If you want to have access to the room and to restrooms when the museum is closed, how will you provide direct entrance from the outside and secure the rest of the museum? Is storage for tables and chairs needed? If so, how much storage space is needed?
- Might this space double as a break room for staff and volunteers?

Support Spaces

These behind-the-scenes spaces enable you to keep programs and services running smoothly in your public and programmatic areas. In addition to fulfilling basic maintenance and storage needs, support spaces also include the work areas that enable you to present dynamic and changing programs that will encourage visitors to return to your museum again and again.

Collections Storage

Considerations for collections storage include security, environmental control, proximity to other areas (called *adjacencies*), and the amount of space needed. Upgrading from poor and crowded storage to good storage conditions often requires twice as much space. Size should be based on both current collections and projected growth for the next fifteen to twenty years. Often, collection donations increase after the expansion or construction of a new facility. Do not underestimate this potential and leave yourself short of storage space. A good rule of thumb is to plan twice as much storage space as exhibit space.

- How much space is desired? How little space would be acceptable? Think in terms not only of square feet but also of volume (cubic feet) needed.
- Are there special space concerns, such as height, for certain types of collections or items?
- Will the varying needs of different collections require more than one environmentally controlled area within the facility? For example, will archival collections be stored separately or combined with library material? Will photos be stored with archives? Do certain materials have special environmental needs, such as a cooler temperature for photos?
- To what other areas do you want the collections storage to have easy access? Exhibit gallery? Loading dock? Exhibit preparation workspace? Research rooms used by the public?

Key to Storage Success

Plan to have twice as much storage space as exhibit space.

Pallet racking (at right) allows safe storage of oversized and heavy objects. Compact storage (at left) travels on rails in the floor, maximizing space by minimizing the need for aisles.

Office(s)

Offices in small and medium-size museums often must balance the need for privacy with proximity for service to patrons and visitors. Privacy should also be balanced against leaving office staff and volunteers too isolated.

- What functions require office space? Collections? Archives? Library? Administration?
- How many staff and volunteers will occupy the office(s)?
- What work will be done in this space?
- Will researchers examine museum collections in this space?
- How many rooms are needed and what size do they need to be?

Workroom

A workroom is a space for relatively clean work on collections. This can include cataloging, labeling, light cleaning, and packing for storage or shipping.

- What types of work will be performed in this space?
- How much space is needed?
- To which spaces is easy access needed? Collections storage? Curatorial offices? Other spaces?
- Will this space provide storage for supplies?

Exhibit Construction Workshop

Whereas the workroom is intended for light work, the workshop is where construction of exhibit materials takes place. The work can be loud, dirty, and dusty.

- What types of work will be performed in this space?
- How much space is needed?
- To which spaces should the workshop be easily accessible? Exhibit gallery? Collections storage? Loading dock? Supplies storage? Other spaces?
- Will noise and dust containment be a concern to prevent disruption to public areas?

Supplies Storage

This storeroom can contain office supplies, packing and shipping supplies, storage boxes, exhibit construction supplies, and other materials. Some or all of these materials may alternatively be stored in separate spaces. For example, office supplies may have allotted storage space within an office; exhibit construction material may be stored in the workshop.

- How big a space is needed? How small would be acceptable?
- For exhibit construction supplies, is easy access needed from the loading dock or another entrance?
- Is easy access needed to the exhibit construction workshop?

Deliveries

How deliveries will be made to the museum should not be an afterthought. It may not be appropriate to use the front door for all deliveries. Planning should address how deliveries might disrupt normal museum activities, including their effect on visitors, collections, volunteers, and staff.

- Can the facility be easily accessed by large trucks?
- Can deliveries be made at ground level or do you need a loading dock?
- Where will food be delivered?

- Will there be space to quarantine collections coming into the building to ensure that they are not infested?
- If there will be deliveries at the front door, is there sufficient space for trucks while unloading?

Quarantine

Isolating collections that are brought into the building for the first time is very important. Items should remain quarantined for observation to ensure that they do not have mold or hold insects that would spread to other collections.

- How big a space is needed? How small would be feasible?
- Can this space have easy access to the entrance where collections will enter the building?

Building Maintenance and Janitorial Services

Every building needs a place to put the equipment and supplies necessary to keep it clean and well maintained. In a museum, a dedicated space is needed to store materials and equipment separate from collections.

- Where can the janitor's closet and sink be located so that they are convenient but will not cause disruption to visitors?
- Where can water pipes be located so that they will not pose any threat to collections?
- Where can maintenance and janitorial supplies be stored conveniently?
- Where can maintenance and janitorial equipment (mops, brooms, tools, lawn mower, snowblower, etc.) be stored conveniently?

Mechanical Room

The mechanical room is where the heating, cooling, and other environmental control equipment resides. This space typically also holds the major electrical panels and is the entry point for water into the building. Generally, water heaters and initial plumbing for water-based fire suppression are also in the mechanical room.

- Where can the mechanical room be located to avoid running water pipes over or through collections use or storage spaces?
- Will noise from the equipment in this space be a problem for adjacent spaces? If so, what adjacencies should be avoided?

- Can the location of the mechanical room allow easy access to bring in replacement or maintenance equipment without disrupting normal museum activities or exhibit spaces?

Elevators

Depending on the design and configuration of your building, an elevator may be needed to access public, programmatic, or support spaces, or all three. The location and size of an elevator needs to be considered both for accessibility of visitors to the museum and for movement of collections into and through the building.

- Is an elevator needed?
- What purpose will it serve? Handicap accessibility for visitors? Moving collections? Other uses?
- How large does the elevator need to be?
- What location will best serve both public and institutional or behind-the-scene uses?

Visualizing Functional and Spatial Relationships

A useful tool to help visualize how functional and spatial relationships can fit together is to create a bubble diagram. Once you have determined what spaces are needed in your facility, a bubble diagram is a quick way to show the basic relationships and connections between the rooms or functions of a building. While a bubble diagram does not necessarily translate directly to a floor plan, it does help clarify which rooms need to be next to which other rooms.

The questions in the preceding section focused on individual spaces. Architects use bubble diagrams to focus more broadly on the flow of traffic through a building. The paths for people and artifacts need to be considered separately, but you must also think about how and where they intersect. Think through the process of bringing in artifacts, processing them, cataloging them, moving them into storage and from storage into the exhibit gallery. For larger projects, creating separate bubble diagrams for different functions or aspects of the organization can be helpful. As you draw a bubble diagram, consider these types of questions:

- How do visitors enter and move about the building?
- How will visitors move through the building to see exhibits?
- How will visitors get to the library? To the restrooms? To the museum store?

- How will school groups enter and move through the building?
- How will people move through the building if they are coming to attend a meeting?
- What is the path for artifacts to flow through the building?

Ordinarily, the building committee works with the architect to develop bubble diagrams. Refer to the list of spatial requirements you identified in the preceding section. You may also refer to and compare your list with spaces listed in appendix 1. Start by selecting a primary function (for example, museum), list it on the board and draw a circle (bubble) around it. Now think of all of the secondary functions that support or interact with that primary function and add them as intersecting bubbles linked to the primary bubble. Some of these bubbles may relate to several others, adding to the complexity of your diagram. Allow the bubbles to grow or shrink in size relative to their functional importance and spatial requirements. Below is an example of a bubble diagram.

Your architect and building committee will refer to the bubble diagram again and again as the architect prepares the preliminary drawings, or schematics, of the building. The schematic drawings will be revised several times until everyone agrees that the plan is satisfactory.

This sample bubble diagram shows the relative sizes and the relationship of components of a typical museum. Many local historical organizations also feature library and archives, museum stores, and more. Since each of these functions has its own set of associated spaces, each can be diagrammed separately.

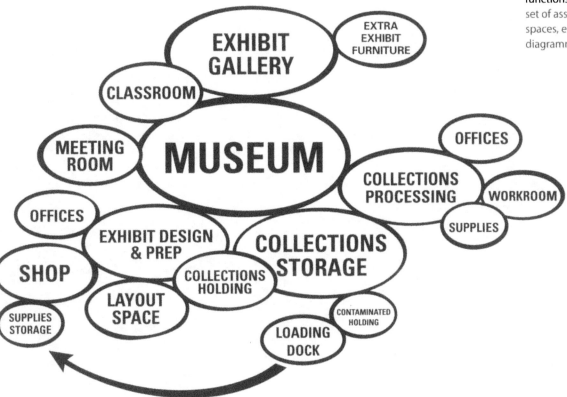

2. THE INITIAL PLAN TAKES SHAPE

Completing the Schematic Design Phase

At the end of the schematic design phase, you will have an idea of the size, or gross square footage, of your construction project. With this figure, you can calculate a preliminary estimate of the cost of the project. To do this, multiply the total square feet by the current dollar figure that the construction industry considers typical for projects with a scope similar to yours. At the time this book is being written, anecdotal evidence suggests that $300 to $400 per square foot is a reasonable number used to estimate project cost.

Gross square feet for proposed project x Cost per square foot = Estimated project cost

If the total is significantly greater than your organization's capacity to raise funds, now is the time to re-examine and revise your decisions about the number, type, and size of spaces. When you are satisfied that the schematics are a good representation of the building as you envision it and that you can afford the project, you conclude this phase by signing off on schematics. Then you are ready to move on to the next phase: design development. But first we will take a more in-depth look at the financial side of your project.

Paying for Your Project

At the end of each design phase, you will sign a document stating that you accept the plans that were generated during that phase. This signals to the architectural firm that you are ready to progress to the next design phase. With the schematic design in hand you will have a much better estimate of construction costs than you had earlier. It is essential, before you sign off on the schematic design phase, to take a step back to evaluate how well the proposal aligns with your ability to pay for the project. A museum construction project has other costs in addition to the actual cost of construction. This chapter largely describes expenses that may not be obvious to someone involved in a construction project for the first time.

Land

The cost of acquiring land can be very significant. If your organization does not already own the land on which your new building or addition will sit, there are a limited number of ways it can be acquired. Having land donated is the most desirable, since that can dramatically reduce the overall cost of a project. Other options are trade, purchase, and long-term lease. Any of these alternatives are viable provided the terms fit your budget.

Travel

Travel may be another project cost. The building committee, director, or board may visit other museums to see examples of an architect's work or to see what other museums have done in their building project. You can learn much by observing the successes and failures of other projects. Good ideas and solutions to issues that may not have occurred to you can often be adapted to your facility.

Architect

A significant portion of the expenses for your project will be for design. A factor that will influence the architect's fee is the level of service provided. Will you have the architect(s) lead your organization through initial planning? Will they only

perform design? Will they also undertake construction management duties, or will you hire an independent firm to do this (see the Project Management section, page 43)?

There are several ways to establish the architect's fee. An architect may charge an hourly rate based on time and materials. This method is commonly used for small projects. Another way is for the fee to be specified as a fixed amount. Most often, an architect's fee is a percentage of the cost of the construction, typically between 5 and 15 percent. Generally, the percentage is lower for larger construction projects. The fee for an architect usually includes engineering costs, since engineers will either be employees of the architectural firm or will be hired by the architect.

Selecting an architect can involve some expense. You may choose to have a competition wherein firms (either open or by invitation) are asked to submit proposals. In some cases, a competition will include payment of a set fee to each of the firms you ask to submit a proposal. Competitions are most often held for larger public projects.

Construction

If you have contracted design work with an architectural firm, construction costs are estimated during the design process and then established by the bid process. If you are working with a design-build firm, the cost of construction is combined with the architect's fees. In addition to size, there are many factors that affect the cost of construction. Some, like whether your building is plain and utilitarian or fancy, are within your control. Others, like whether materials such as steel and concrete are readily available or scarce, are beyond your control.

Contingency Fund

It is standard practice to set aside a percentage of the total budget for contingencies. This fund covers change orders and unexpected costs of a project. An example of an unexpected cost is the mitigation of hazardous materials discovered during site preparation. Another example is the discovery during excavation of water flowing through the site from a previously unknown source. On one project this required the design and construction of a water diversion system, all of which occurred after the construction contract had been let.

If, as the project progresses, you see that you will not need all of the contingency funds for unexpected costs, you may elect to use some for add-alternates. An *add-alternate* is a feature that was not included in the base bid for the project but that was designed and bid as a separate item to enable the project to stay within budget. Examples of add-alternates might be upgrading a piece of

equipment such as an elevator, using a more expensive material or finish, or adding equipment for a special cold storage room for photographic collections.

Contingency funds are also used to pay for change orders. Once a building has been bid and contracts signed, any deviation from the plan has a cost. This additional cost is detailed in a change order, which is basically a purchase order that amends the contract. A change may be the result of rethinking about something that could be improved, realizing that a function or space was overlooked, or discovering a mistake. This may require additional architectural or engineering design as well as additional materials and labor. You will pay for the redesign (yes, you will pay the architect or engineer to correct mistakes that they made earlier!) as well as labor and materials to accomplish the change. If changes are made prior to completion and occupancy, they usually are accomplished by the firms already under contract and therefore do not go out for competitive bids. This means that you will pay a premium for these changes, another reason to keep them to an absolute minimum.

Project Management

Project, or construction, management is another expense of a construction project. A professional construction manager may be hired during a complex design process to assist the institution in evaluating architectural and engineering recommendations or may join the project later, such as at the beginning of actual construction to oversee the building process. A construction manager can also help manage the schedule, ensuring, for example, that all of the appropriate people have reviewed plans, specifications, or other documents in a timely manner so that the project is not delayed. A delay in sign-offs can have a ripple effect that impacts all of the work that follows.

In some cases, museum staff who manage small projects may recognize that this is a time-consuming job that requires a special skill set. If you are working with a design-build firm, project management is generally included in the package price. If not, your architect may offer this service for an additional fee. Or you may elect to hire a firm that specializes in construction management. (See chapter 7, page 115, for more on construction management.)

Consultants

Consultants are often hired to assist in planning, to perform evaluations, and to make recommendations in specialized areas that supplement the work of the architect. In some cases, a consultant for exhibit planning and production is built into the cost of a new facility; in others, you may want to enlist outside expertise. Consultants can provide myriad services. Some of these include

- Financial feasibility studies
- Project planning
- Producing a facility program
- Fundraising
- Lighting
- Acoustic analysis and design
- Elevator selection and design
- Food service and restaurant design
- Exhibit planning and production
- Security design
- Landscape design and installation
- Review and evaluation of mechanical systems (heating, ventilation, air conditioning)
- Building commissioning (explained in chapter 8)
- Vibration and seismic control analysis and design
- Public relations
- Signage
- Planning an opening celebration

Consultants can be expensive, so it is important to prioritize the specialties you are considering. As you prioritize, remember that consultants' fees can pay for themselves in the long run by sparing expensive mistakes. Recognize which specialties are the most crucial to the success of your project. For example, while hiring a consultant to help design the museum's specialized heating, ventilation, and air conditioning (HVAC) system may be essential for the preservation of your collections, you might be able to use a local gardening club to help with landscaping design, which is less important to the museum's function.

How to Find Consultants

Finding specialized consultants may not be easy, particularly if you are not located in or near a major metropolitan area. The following list offers some starting points for networking to find consultants:

▶ If your architect has sufficient experience, he or she may be able to give you suggestions.

▶ Contact larger museum organizations that have construction experience to get recommendations.

▶ Talk to someone at your state historical society or state agency for history who has used specialized consultants.

▶ The Field Services Alliance (FSA), an affinity group of the American Association for State and Local History, has knowledgeable members who may be able to help you find consultants (go to http://www.aaslh.org/FSA/).

Furnishings and Equipment

New furnishings and equipment that are not included as built-ins in the construction design may be a substantial expense beyond the cost of design and construction. Items you may consider purchasing separately include various kinds of furniture, equipment for moving collections, and maintenance equipment. Some specific items you may want to consider include

- Office furniture
- Movable partitions
- Storage shelving and cabinets
- Worktables
- Rolling ladders
- Carts
- Pallet jacks
- Furnishings for a restaurant and a museum store
- Cash registers
- Interior and exterior signage
- Loading dock equipment
- Maintenance equipment for the building
- Maintenance equipment for the mechanical systems
- Maintenance equipment for the grounds

Relocation Expenses

Moving into a new building costs money. You may choose to pack collections yourself to ensure they are handled with proper care and hire a mover just to transport them. You may, however, need to hire additional labor to complete the packing in a timely manner. Or you may choose to have a professional moving company pack, transport, and unpack.

The cost of hiring professional movers to transport collections, furnishings, and equipment may be substantial. Extremely large or heavy items (e.g., sculpture, mining equipment, boats, cabins, railroad cars, or other large vehicles) may require experienced specialty riggers, who will provide expertise and any necessary special equipment and vehicles.

Operating Expenses

A construction project that expands facilities will almost always result in increased annual operating expenses. Anticipating these costs and knowing how you will pay for them eases the transition to the new facility.

Hired professional movers, staff, or trained volunteers using appropriate equipment will keep your collections safe when shifting objects before, during, and after a construction project.

If your project will create new programs and services that your organization has not previously provided, you will likely need additional staff. You can also expect increased expenses for annual maintenance, for utilities, and for insurance. You might mitigate some of the utilities costs by incorporating energy-efficient systems in the building, but an energy-efficient building that is much larger than the former building will still cost more to operate.

How will you pay for these increased costs? One option to consider is adding an endowment component to the capital campaign for the project. An *endowment* is a fund that is set aside and invested, with annual income earned through prudent investments. The income is sometimes dedicated for specific programs but other times is simply allocated for operating expenses. Keep in mind that a relatively large endowment will be needed to produce a steady stream of annual income. For example, $1 million earning 5 percent per year (a percentage commonly used to estimate income) would yield $50,000 annually.

Hidden Costs

One cost in a construction project for which you will not need to raise funds is the time that your staff spends during the planning, design, and construction phases. Recognize that the time your personnel devote to the project will take

Estimating Operational Costs

One way to estimate operational costs for increased square footage is to determine the current amount spent per gross square foot. For example, let's assume your organization spends an average of $32,500 per year and operates two buildings with a combined footprint of 5,850 square feet. Your annual cost per square foot is $5.56 ($32,500 divided by 5,850).

Current annual operating expenses
÷ Square footage of building(s) operated

= Annual operating cost per square foot

If the organization adds an addition or moves to a new facility and thereby gains 4,000 additional square feet, where will the organization find an additional $22,240 ($5.56 multiplied by 4,000) to maintain the same level of services and programs that it currently provides?

Annual operating cost per square foot
× Additional square feet added on in construction

= Projected annual operating expenses after construction

Understand that this is a device to get you to think about and estimate increased costs. Realities differ widely from one organization to the next.

time away from their normal duties and responsibilities. They will spend a significant amount of time attending meetings, reviewing plans and specifications, making lists, measuring, and doing various kinds of research.

Making this obvious point is not to suggest that staff should not be involved. Quite the contrary: the more staff input and involvement, the better the architect and engineers will be able to design a building that fits the vision and needs of your organization. More review also means that more mistakes and oversights will be caught. Correcting mistakes before construction documents are accepted and before the project goes to bid is much less expensive than it will be once construction has begun. But recognize that staff may need to have their assignments and work plans adjusted to enable them to participate fully in the construction project.

The Next Phase

Having given careful thought to the cost of your project, you are ready to turn to the next phase: design development. Like schematic design, design development will follow an iterative process that builds on what has been done earlier, this time resulting in much more detail and specificity.

Getting Down to the Details— Design Development

In the design development phase, the preliminary drawings from the schematic phase are developed into detailed and fully articulated plans. While your architect, contractor, or design team does much of the work, the building committee continues to have a critical role. It is extremely important that the building committee actively participate in this process. The committee needs to be an informed consumer to ensure that the design accurately reflects your vision of the building and addresses all of its functional requirements. This is an intense stage during which implementation of major decisions as well as myriad details must be carefully considered. Throughout design development you will have many opportunities—in meetings and in reviews of design drawings—to help guide the designers to create a successful design. This chapter gives an overview of the issues considered during design development. Chapter 5 carries the discussion of design development into the specific details required for a successful museum or archive environment.

The choices and decisions you will face during this phase of your project relate to two major aspects of the design: architectural design and engineering design. The architectural design addresses image, function, spatial relationships, and traffic flow. The engineering design addresses the structural, mechanical, and electrical elements of the building. A truly successful design balances the aspects of form and function in a manner that does not compromise the goals or needs of either.

At the end of the design development phase, your project design will be fully developed and you will sign off to indicate your approval of the plan. This signature authorizes the architect to prepare the construction documents that general contractors will bid on.

Design Development Documents

Your architect and engineers will propose designs in numerous drawings. Separate sets of drawings are created for structural, for mechanical (HVAC), and for electrical elements, and they are coordinated with the architectural drawings. For each aspect of the

> ### Key to Design Development Success
>
> Remember that the building committee and museum staff understand the functional aspect of your operation better and in more detail than your architect and other members of the design team. Keep a clear eye on function throughout the design process to ensure that form does not outweigh function.

Types of Drawings

► Plans

► Elevations

► Cross-sections

► Details

(See appendix 2 for a complete reference guide to drawings and some of the many symbols they contain.)

design, drawings show various views: floor plans, elevations, and cross-sections as necessary.

Specifications and schedules also begin to be generated during design development. These are lists of every type of material and piece of equipment that will go into the building. The schedules and specifications contain room-by-room details, such as exact ceiling height, door height and width, and the type of paint or other finish that will go on floors, walls, and ceilings. Each light fixture, every faucet, every window shade or blind, every single component of the HVAC system, anything that is built into the building—all must be listed with their requirements and specifications together with preferred brands and model numbers.

The selection of room finishes, furniture, and cabinetry will have a significant effect on both the look and the cost of your building. Finishes can feel fancy or plain, formal or informal, lavish or frugal, which means these choices affect how the public perceives your organization. Obviously, these choices will also impact the cost of your project. Work with your architect or interior designer to select finishes that will help achieve your vision for the building while being mindful of your budget.

Everyone on the building committee and other appropriate staff should carefully review all drawings, specifications, and schedules. How well your building functions will depend not only on the layout but also on the functioning and coordination of the sum of all of the hundreds of details that are contained in the specifications and schedules. At each step of design development, the reviewers should point out all flaws or concerns with the designs

Key to Accurate Design Documents

Carefully review all schedules and specifications, as well as all drawings. All documents must be completely accurate for your building to function as envisioned.

so that they may be discussed and changed or corrected before proceeding to the next phase of design. The building committee chairperson is responsible for communicating all findings in writing to the architect. (See appendix 2 for a detailed explanation of drawings, specifications, and schedules.)

Regulatory Codes

Among the details addressed during design development are regulatory, or building, codes. These relate to local building regulations established for safety, for zoning, and for livability. During design development, your architect and any other designers you employ are responsible for meeting code requirements. Regulatory inspectors will review your project plan on paper to make sure it is

within legal parameters before issuing a construction permit. Later, during and after construction, inspectors will continue to review your project to make sure it continues to follow regulatory codes.

Detailing Each Functional Space

During design development, the building committee and architect analyze every space to a much more detailed level than was performed during schematics. The following lists revisit the same spaces reviewed in chapter 2 for schematic design. Whereas the questions during schematic design were relatively broad and general, now, in design development, the questions are very specific. You will work with your architect to nail down every single detail that goes into the design of each aspect of your facility.

Public Spaces

Entrance(s)/Lobby

In schematic design you listed the functions that the main entrance will serve. In design development you plan the details needed to meet these functions.

- Is the main entrance close to parking?
- Will buses be able to drop visitors close to the main entrance?
- How much space is sufficient for groups to assemble?
- Do you need a vestibule to help maintain a stable environment within the building?
- What provisions have been made to keep mud and snow from being carried in during inclement weather?
- What provisions have been made for handicapped accessibility? Do they meet the Americans with Disability Act (ADA) requirements?
- What security measures are to be incorporated at the entrance?
- What lighting will be incorporated for visibility and security? How will lighting be controlled if light-sensitive collections will be exhibited in the lobby?
- What exterior signage will direct visitors to the entrance?

Information Desk

In schematic design you thought about the size and location of and duties that will be performed at the information desk. In design development you refine these ideas and plan the architectural details that will serve these functions and project a certain image to your visitors.

Accessible entrances to historic properties should minimize visual impact. Note how the period-appropriate landscaping hides the ramp as it approaches the building.

- Is the size and shape of the information desk appropriate based on the number and type of functions that it will serve, such as greeting visitors, ticketing, sales, answering telephones, security, providing information about events and services?
- Are counters low enough to comply with ADA?
- Where will the information desk be located? Can it be seen easily from the main entrance, from entry to the exhibit gallery, from the museum store?
- What do you want the information desk to look like? Should it be formal or informal in appearance? What kinds of materials and finishes do you want?
- What are the electrical, telephone, and computer requirements? Where should they be located?
- Will you have monitors for security cameras at the information desk? How will monitors be located so that volunteers or staff working at the desk can see them while they perform their other tasks?

Major ramping to accommodate mobility can visually distract from a historic building.

- Consider any need for special lighting. How should the information desk be illuminated to help visitors identify it as the place where they will be able to get information? What additional lighting will be needed for volunteers or staff to do their work?
- What kind of storage is needed? How much is needed?

Museum Store

In schematic design you considered whether to have a store, where to locate it, and, in general, what to stock. In design development you plan how to configure, display, store, and check out items.

- What type and how many built-in display furnishings will be installed?
- What display lighting is needed to coordinate with the furnishings?
- What kind of equipment and specialized furniture will you need at the checkout station? Cash register? Telephone? Credit card reader? Computer?

Architects and designers often favor large, dramatic windows but fail to consider the effect of light on museum artifacts. This design has resulted in significant costs to the organization for controlling light and keeping precipitation out of the building. It has also prevented the museum from displaying any light-sensitive items in this space.

- Are counters low enough and aisles wide enough to comply with ADA?
- How will the store be secured when not in use (e.g., when the meeting room is being used while the museum is closed)?
- Have you provided sufficient storage space for stock? For supplies?

Coatroom

In schematic design you considered whether to have a coatroom and, if so, the size and location. In design development you finalize size and location and plan the furnishings.

- Is the size and location appropriate for your needs?
- Is the location suitable for use off-hours when the meeting room is being used while other facilities, such as the library or museum, are closed?
- Plan and review furnishings: coatracks, shelves, lockers, etc. All must comply with ADA.
- What provisions have been made for visitors (e.g., lockers) to secure possessions that are not allowed in the library or exhibit gallery?

Restrooms

In schematic design you discussed location, gender specific versus unisex, and public versus staff restrooms. In design development you select plumbing fixtures, lighting, and equipment.

- Review location, size, and number of restrooms. Do they meet your needs?
- Will the location force water pipes to run in or above collections use or storage areas? If so, can the restroom(s) or pipes be moved to avoid this potential risk to collections?
- What equipment will you select? Paper towel dispensers? Electric hand dryers? Automatic faucets? Soap dispensers? Diaper changing station(s)? Drinking fountains?
- Will the lights have occupancy sensors for energy conservation?
- Verify compliance of space, layout, and equipment with ADA requirements.

Food

In schematic design you contemplated whether and where to allow food. In design development you create pathways for routing food and waste and plan logistics for equipment, mechanical, and utility needs.

- Review the appropriateness of size and location for the type of food service and eating areas you have decided on.
- What is the route for entry of food? For waste disposal? How convenient are these routes? Are the routes likely to bring contamination into sensitive areas of the building?
- What equipment is needed?
- What types of electrical service are needed? Where will they be located?
- What are the ventilation needs? Ensure that exhaust is well clear of fresh air intakes.
- Where will water be? Is the space adjacent to a collections use or storage area? If so, design pipes not to run over collections to avoid the potential risk of accidental damage.
- Verify compliance of cabinets, counters, layout, and equipment with ADA requirements.

Parking Lot

In schematic design you calculated capacity and location for parking. In design development you look more specifically at how the parking will be used and how to make it efficient, safe, and attractive.

- Review how big a parking lot is needed. How will it accommodate both cars and buses?
- What is the proximity to the public museum entrance?
- Will the site require steps or a ramp from parking to the entrance? If so, verify design compliance with ADA requirements.
- What provisions have been made for water runoff?
- How will lighting facilitate and provide security for nighttime parking?
- Will you have cameras for security?
- How will the lot be landscaped?

Programmatic Spaces

Library and Archives

The books, photographs, maps, business and government records, letters, diaries, and manuscripts used by the public for research are for the most part irreplaceable. In schematic design you thought about how this research service would be accessed and used and what equipment and personnel would be needed. During design development you will look more closely at protecting your collections while making them accessible to researchers.

- Review size to ensure it not only accommodates your collections but also allows for future growth.
- How efficient is it to move collections to and from secure collections storage?
- How well does the layout enable adequate observation by staff for security of collections?
- Review quantity and location of computer connections. Do they meet your projected needs?
- Is there sufficient space and appropriate lighting for microfilm reader/ printers and public-access computers?
- What provision is made for protecting collections from excessive exposure to light?
- What furnishings are needed? Tables? Chairs? Shelves? (Do a preliminary layout to determine quantity.)
- What lighting will you use and how will it be configured? (The preliminary layout you do for furnishings may also affect the lighting design.)

- Where will the photocopy machine be located? Will it be available for use by researchers or just staff?
- Will you provide space and equipment for self-service to photograph items from the collections?
- Verify compliance of entry, layout, furnishings, and equipment with ADA requirements.

Exhibit Gallery

In schematic design you stipulated the types of exhibits, the size and flexibility of galleries, the traffic flow, and adjacencies. Now you are ready to be more specific about these requirements. Especially important are the flexibility of the space(s) and the ability to control light, temperature, and humidity. (See chapter 5 for a more complete discussion on environmental control.)

- Review location, adjacencies, and traffic flow for people and for collections to ensure all are configured to meet your needs.
- Review size of the gallery. Can the space be easily divided to allow for multiple small exhibits? Will structural elements (e.g., support columns) limit flexibility of the space?
- Does the gallery lighting plan address the needs of visitors, of collections preservation, of changing exhibits? (See pages 87–96 for a discussion on lighting.)
- Is the gallery windowless to prevent damage to collections from daylight?
- Is the ceiling high enough to accommodate tall items? (See "Calculate Clear Space" on page 61.)
- Are there any special requirements for floor loading for an extremely heavy object that you are planning to use or might use in the future?
- Is it easy to mount items to permanent walls? Can these walls be patched easily?
- Will the flooring fatigue visitors? Will the flooring be easy to clean and maintain? Will the flooring be noisy?
- Will the floor, ceiling, and wall finishes selected minimize potential damage to the collections from off-gassing and dust? (See pages 103–7 for a discussion on choice of materials.)
- Will the space be noisy, or "live," with sound (from people or audio-visual programs) from one area distracting visitors in other parts of the gallery? Do special provisions need to be made to dampen sound? (A specialist in sound engineering can address this.)

- How can the area be isolated during exhibit construction to prevent dust and debris from spreading into other areas?
- Are water pipes (other than fire suppression) routed to avoid passing over or through exhibit galleries?
- How have security concerns been addressed? (See pages 99–103 for a discussion on security.)

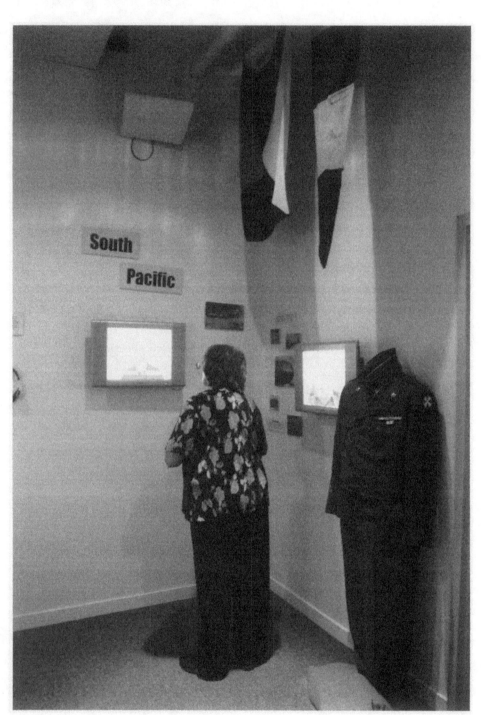

Sound control devices—with speakers that direct the audio—can be used in galleries to prevent "noise bleed" between adjacent components.

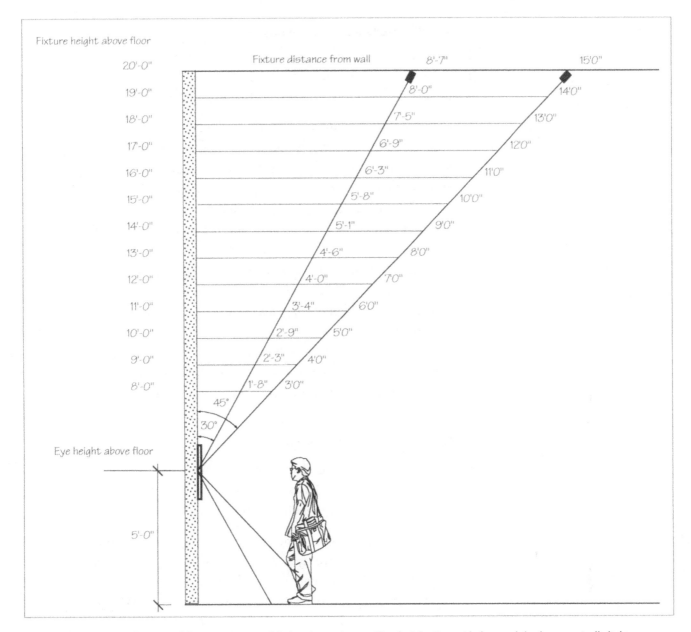

The following labels appear in the figure:

Fixture height above floor

Fixture distance from wall 8'-7" 15'0"

20'-0"
19'-0" 8'-0" 14'0"
18'-0" 7'-5" 13'0"
17'-0" 6'-9" 12'0"
16'-0" 6'-3" 11'0"
15'-0" 5'-8" 10'0"
14'-0" 5'-1" 9'0"
13'-0" 4'-6" 8'0"
12'-0" 4'-0" 7'0"
11'-0" 3'-4" 6'0"
10'-0" 2'-9" 5'0"
9'-0" 2'-3" 4'0"
8'-0" 1'-8" 3'0"

45°
30°

Eye height above floor

5'-0"

The optimum distance from a wall for mounting track lights depends on ceiling height. To avoid glare and shadows, typically light fixtures are angled between 30 and 45 degrees relative to the wall.

Classroom

In schematic design you considered whether you need a classroom and, if so, the location, size, and storage needs. In design development you plan details for equipment, mechanicals, and storage to ensure the space will meet your needs.

- Do you want the space to be capable of being divided into smaller spaces? If so, how sturdy and soundproof should the dividers be?
- What audiovisual equipment should the space accommodate?
- What other equipment needs to be accommodated? Whiteboard? Projection screen? Large map? Sinks? Ovens? Stoves?
- If there are windows, what provisions will you have for blacking them out?
- Is the ventilation sufficient for large groups of active children?
- Will the floors be carpeted?
- Is the lighting plan flexible to allow for different types of activities and setups?
- Does the electrical plan include more outlets than you think you will need? (Now is the time to add all the outlets possible.)
- Will storage for supplies and teaching aids be in the room or nearby?

Meeting or Community Room

In schematic design you decided whether to have a meeting room and, if so, the size, functions, and accessibility for this space. Design development will configure the space to meet your requirements.

- Do you want the space to be capable of being divided into smaller spaces? If so, how sturdy and soundproof should the dividers be?
- What audiovisual equipment should the space accommodate?
- What other equipment needs to be accommodated? Whiteboard? Projection screen? Sinks? Ovens? Stoves?
- If there are windows, what provisions will you have for blacking them out?
- Will the floors be carpeted?
- Is the lighting plan flexible to allow for different types of activities and setups?
- Does the electrical plan include more outlets than you think you will need? (Now is the time to install all the outlets possible.)
- Is storage for extra tables and chairs convenient?
- If food will be allowed in this room, have adequate plans been made to prepare or stage food?
- If this room will be used when the museum is closed, has access to restrooms and direct entrance from the outside been accommodated?

Support Spaces

Collections Storage

In schematic design you calculated ideal storage capacity based on future projections for collections growth. In design development you will plan the space and ensure it meets your needs. Not only the quantity but also the kinds of items in your collections will affect the equipment and storage furniture you use, which in turn will affect the size and configuration of storage.

- Review size. Does it meet the goal of being twice as large as your exhibit space?
- Are access and adjacencies convenient for moving collections?
- Will structural elements (e.g., support columns) hamper efficient use of the space?
- What are your requirements for ceiling height and clear space? (See "Calculate Clear Space," below.)
- Based on the items in your collections, what size and quantity of equipment and storage furniture will you need?
- Is the placement of lighting and sprinklers compatible with your proposed layout of shelving and cabinets?
- Are doors wide enough and tall enough?

Key to Storage Success

If your project has drifted over budget and cuts are necessary, be cautious about sacrificing this behind-the-scenes space for more visible, public spaces. It will undoubtedly be a long time before your organization will be able to add storage space again.

Key to Success: Calculate Clear Space

In order to move collections around the building safely, ceiling clearance is critical. The distance from the floor to the bottom of anything that hangs from the ceiling is called *clear space*. If a duct or a sprinkler head hangs down two feet from the ceiling, then the ceiling height listed in the room schedules is not the relevant dimension to check. You must check clear space in hallways and rooms as well as door heights to ensure that you will be able to move collections throughout the building unhindered. To determine necessary clear space:

1. Identify the tallest object in your collections and measure its height.
2. Measure the height of the bed of the cart that you would use to move this item.
3. Add the height of the object, the cart's bed height, plus one additional foot. The total of these three numbers is the minimum clear space you need to safely move objects through your building.

Planning sufficient clear space in halls and doorways will allow you to move oversized objects safely.

- Will the preservation requirements for high-quality storage of museum, library, and archival collections be met by the HVAC system being designed? (See pages 69–86 for a discussion on HVAC requirements and standards. It may be helpful to have the preliminary design reviewed by an independent expert with experience in HVAC design for museums, libraries, and archives.)
- Will lighting systems in storage spaces protect the collections from damage due to excessive exposure to light? (See pages 87–96 for a discussion about lighting.)
- Will the floor, ceiling, and wall finishes selected minimize potential damage to the collections from off-gassing and dust? (See pages 103–7 for a discussion on choice of materials.)
- What security measures have been designed for storage spaces? Is access secure yet convenient? Will there be electronic security devices in addition to high-quality locks? (See pages 99–103 for a discussion on security.)
- Are water pipes (other than fire suppression) routed to avoid passing over or through collections storage?
- Have provisions been made to ensure that the space has sufficient drainage in the event that water enters the space?

Office(s)

In schematic design you focused on size, location, and functions of office space. In design development you finalize these considerations and plan for lighting and electrical needs.

- Review the quantity, size, and location of staff offices to ensure they meet your needs.
- Are the locations of electrical outlets and computer connections sufficient to support a computer network?
- Is the lighting intensity and UV filtration appropriate for collections that may be present? (See pages 87–96 for a discussion on lighting.)
- If the office will include storage for supplies, has enough space been planned?
- If this space will provide storage for supplies, will shelves or cabinets be built in?

Workroom

In schematic design you determined what tasks would be performed in this space. In design development you specify the details needed to accommodate these tasks.

- If collections will be worked on within this space, are the doors wide enough and tall enough? Is the ceiling height sufficient for objects to clear fixtures that hang from the ceiling? (See "Calculate Clear Space" on page 61.)
- If collections will be worked on within this space, is it window free to prevent light damage?
- Will this space have built-in cabinets or counters? Other furnishings?
- Will this space have a sink?
- What floor finish would be best?
- Is the lighting intensity and UV filtration appropriate for collections that may be present? (See pages 87–96 for a discussion on lighting.)
- Is the layout of lighting appropriate for the location and type of work that will be done in this space?
- Are electrical outlets abundant?
- If a computer network is planned, are connection points sufficient to allow flexibility?
- If paint, solvents, or adhesives will be used in this space, does the ventilation meet safety and health code requirements?

Exhibit Construction Workshop

In schematic design you considered size, location, and type of work done in this space. In design development you address meeting the needs of collections; providing equipment, utilities, and mechanical systems; and containing the mess and noise. Ventilation is a key component.

- What size doors and how high a ceiling is needed? (See "Calculate Clear Space" on page 61.)
- What equipment will go into or be used in this space and what utilities are needed for it?
- How will dust or dirt from this space be contained and exhausted to prevent it from getting into clean spaces?
- If you expect to be using paint or adhesives, have you made provision for proper ventilation?
- What floor finish is most appropriate?

- Will there be a sink in this space? Will that force water pipes over or through collections use or storage spaces?
- Do special provisions need to be made to contain noise generated in this space?

Supplies Storage

In schematic design you considered size and proximity to other spaces. In design development you ensure that the size and access will accommodate your needs.

- Has adequate provision been made for collections storage supplies? For office supplies?
- Is the door and ceiling clear space adequate for exhibit construction supplies such as sheets of plywood? (See "Calculate Clear Space" on page 61.)
- Is the door size adequate for excess exhibit display furniture, such as cases and temporary walls or panels?

Deliveries

In schematic design you addressed the basic needs for deliveries. In design development you consider logistical details.

- Do you need a dock leveler to accommodate trucks of different heights?
- What security measures are necessary to control access? (See pages 99–103 for a discussion about security.)
- What communication has been designed to notify staff that someone is at the door?
- What has been done to prevent outside air from compromising the environment in nearby controlled spaces?

Quarantine

A quarantine room is an isolation space where incoming material is kept until it is established that it is free of infestation or mold. If treatment is necessary it is usually accomplished in this room. In schematic design you determined the size and access for quarantine. In design development you detail the specifications that will ensure containment.

- Are the construction details (such as how the wall meets the floor) sufficient to contain any pests?

- Have door seals and sweeps been designed to prevent pests from escaping quarantine?
- Does exhaust ventilation go directly outside? As chemicals might be used, exhaust from this room should not be recirculated to other spaces in the building.
- If you plan to install a freezer for pest control purposes, is the requisite electrical service specified and located where needed?

Building Maintenance and Janitorial Service

In schematic design you considered access issues. In design development you ensure that the size, location, and function will meet all requirements.

- Review location to ensure convenience without disruption to visitors.
- Will the location route water pipes over, through, or adjacent to artifact use and storage spaces? If so, what changes are necessary to avoid this?
- Review size to ensure sufficient capacity for supplies, for cleaning equipment, and for building and grounds maintenance equipment.
- Have provisions been made for storing flammable and toxic supplies? What are the building code requirements for flammables? What are the OSHA requirements for flammable and toxic material?

Mechanical Room(s)

In schematic design you thought about how location of the mechanical room would affect access, noise, and water concerns. In design development you specify the details needed to address these concerns.

- Review location: does it meet your access needs?
- Does the room need to specify soundproofing materials to contain noise?
- Review the routing of water pipes to and from this space to ensure they do not pass over, through, or adjacent to artifact use and storage spaces.
- Are doors sized sufficiently for repairing and replacing large equipment?
- Does the location and layout present any barriers for equipment maintenance?
- Are the floor drains adequate?
- Have provisions been made for storing flammable and toxic maintenance supplies?

Elevators

In schematic design you decided whether to have an elevator and, if so, the size, function, and location. In design development you review the proposed model and finishes.

- Review the size and location to ensure your needs are addressed.
- Are the type, speed, and finishes of the elevator a good match for your application and for your budget?

Special Design Development Issues for Museums

Museum buildings are designed to protect the historical collections that are central to your mission. In this respect, museums are quite different from other buildings. Designing the systems specific to museums means you will need to be familiar with some specialized topics. The next chapter continues the design development phase, focusing in detail on the systems that make museums unique.

Museum Environment— What Makes a Museum Building Special

Museum environments are different from other buildings because collections often have more stringent requirements for their preservation than most people need in their day-to-day lives. The environment within a building is defined by several factors: temperature, relative humidity and dew point, the quantity of airborne particulates and gaseous pollutants, and light quality and levels. Controlling these variables within relatively narrow ranges makes designing a museum environment more challenging than most other buildings.

Fire suppression and security are other important aspects of the total environment of your facility, and the selection of some of the materials used to build and finish the inside of the building may impact the life of your collections. This chapter discusses all the topics you need to address during design development to ensure maximum preservation of your collections.

Heating, Ventilation, and Air Conditioning (HVAC)

Climate control is a core issue in museum design and renovation. Temperature and humidity in the museum affect the collections and directly influence the visitors' experience. If conditions are right, visitors never give them a thought. If conditions are too hot, too cold, or too humid, visitors will feel uncomfortable. Their concentration will be affected, they may shorten their visit, and they are less likely to return. While a visitor is in the building for a few hours, the collections are there indefinitely, and the environment has an effect on every item in the collections. Seemingly small deviations from specified conditions can add up over the years to significant damage.

Temperature and humidity are not the only concerns; dust and gaseous air pollutants also damage collections. Controlling the environment can be thought of as a conservation treatment for the entire collection. Instead of spending money on a conservation treatment for one or several items each year, you are spending money to control the overall environment and minimize deterioration for the entire collection. The better the environment, the better the collections' condition will be in the future.

Your facility's HVAC system is the dominant factor in determining what kind of environment you will have. The better suited your HVAC system is to the needs of your facility, the better controlled your environment will be. Like other aspects of museum design, museum HVAC systems may be an unfamiliar topic to your architect. This section will help you understand the key considerations to discuss with your architect and an HVAC engineer.

HVAC Functions

A museum HVAC system performs six basic functions:

▶ Heating

▶ Cooling

▶ Humidification

▶ Dehumidification

▶ Ventilation

▶ Filtration

Most of these functions are self-explanatory. Heating is used when the air temperature inside the building falls below a specific setting, and cooling when the temperature rises above a set point. Humidification adds moisture when the air gets too dry, and dehumidification removes moisture from the air. Ventilation brings in and circulates fresh air. Filtration is necessary to remove particulates from the air, since dust particles can soil and damage sensitive collections. Filtration may also be employed to remove gaseous pollutants from the air if local conditions warrant.

In an ideal world, museum collections would be stored under constant conditions. The challenge to the museum HVAC engineer is to design a system that meets the needs of both people and collections. While people adapt relatively easily to different or changing environmental conditions, the needs of collections may be less flexible. A system that maintains constant temperature and humidity and performs a very high degree of filtration is expensive to install and operate. Fortunately, however, some fluctuations are acceptable.

There are many types of climate-control systems, each with advantages and disadvantages. In general, a good system will maintain the indoor environment at fairly constant conditions regardless of outdoor conditions. How this is accomplished depends on several factors: the outdoor environment where the building is located, the building's design and quality of materials and construction, the environmental parameters that you specify for the building, the HVAC design, and the quality of the HVAC equipment installation. Often, budget constraints affect how you address these factors. Not surprisingly, the better control an HVAC system provides the more expensive it is.

How, you may ask, does one go about planning an HVAC system that addresses all these factors and that meets the needs of your collections? While this book cannot begin to assess specific HVAC models, the following sections

The visual impact of newly installed ductwork (at right) was minimized by a surround designed to blend with the existing interior.

Keys to HVAC Success

A well-designed museum HVAC system meets the following criteria:

- ▣ Maintains temperature and humidity within a specified range of fluctuation.

- ▣ Limits particulates (dust) to a specified standard.

- ▣ Filters gaseous air pollutants, if necessary, to specified levels.

- ▣ Monitors and records actual conditions in the spaces.

- ▣ Detects and communicates when the system is not functioning properly.

- ▣ Locates water pipes away from collections storage and use areas to avoid exposing collections to potential water damage.

- ▣ Runs quietly and causes minimal vibration.

- ▣ Is reliable and durable.

- ▣ Has reasonable operating costs (both energy and maintenance).

- ▣ Is easy to maintain, to troubleshoot and correct problems, to repair, and to get replacement parts by or from on-site personnel and local vendors.

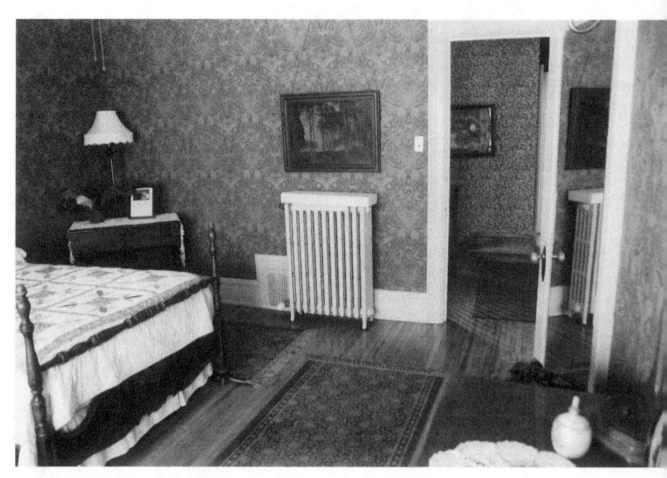

A discreet modern control added at bottom left to the historic radiator allows for a more precise and energy-efficient temperature setting in each room rather than in large zones.

introduce the types of HVAC systems and some basic considerations for museums that will help inform your search for the right system. Integral to the design development of your HVAC system will be detailed discussions with your architect and an HVAC engineer.

Forced Air Systems

A simple HVAC system may be like the one found in many residential buildings: a forced air system consisting of a furnace powered by oil, gas (natural or propane), or electricity. The system heats air and uses a fan to distribute the warm air through a network of ducts. The capability of this system can be expanded to include refrigeration (often referred to as *air conditioning*) to cool the air during the summer. A refrigeration system will also dehumidify air. A forced air system (furnace, fan, and ducts) might also be expanded to incorporate humidification to add moisture to the air during periods of low ambient humidity. Forced air systems include filters to remove dust particles from the air, and they can also be fitted with filters to remove gaseous pollutants.

Air Handler and Chiller Systems with Boiler

Furnaces are generally unable to meet the HVAC requirements of larger buildings. Instead, these facilities usually have a boiler to create heat and humidity, a chiller to produce cool air, and large fans called *air handlers* to distribute the conditioned air through ductwork. The air handlers also incorporate filters for particulates and sometimes also for gaseous pollutants. If the building is large or serves multiple functions, there will be several zones, each with a specified set of parameters and each served by a dedicated air handler. If there are multiple different spaces served by a single air handler, additional coils and airflow control dampers may be incorporated to adjust air temperature and humidity to the required levels just before entering each space. This may be done while maintaining a specified constant volume of air entering the room or by using a variable air volume (VAV) device. While VAV systems often consume significantly less energy than a constant volume system, constant volume systems can be more dependable since they have fewer pieces of equipment that need maintenance. If it is well designed, a constant volume system will also do a better job of maintaining conditions with less fluctuation than systems incorporating VAV devices.

Packaged HVAC with Forced Air

Packaged HVAC units are used to control heating, cooling, and humidity in a single space such as a storage room. These units are frequently used in computer rooms and therefore are sometimes referred to as CRAC (computer room air conditioning) units or as Liebert units after the company that developed them. Packaged HVAC units do not provide a complete system; they require a forced air system to circulate the air and to bring in outside air. A packaged HVAC unit can be a good application for a storage room upgrade or as a retrofit when there is an existing forced air system in place.

Fan Coil Units

Another method of controlling temperature and humidity is with fan coil units. These devices use hot and chilled water supplied to heating and cooling coils to temper air that a fan then delivers directly into a space. These units are frequently ceiling hung and usually do not use ducts. Due to the noise inherent with this type of system, they are most often used in unoccupied spaces like garages, loading docks, corridors, and sometimes storage spaces.

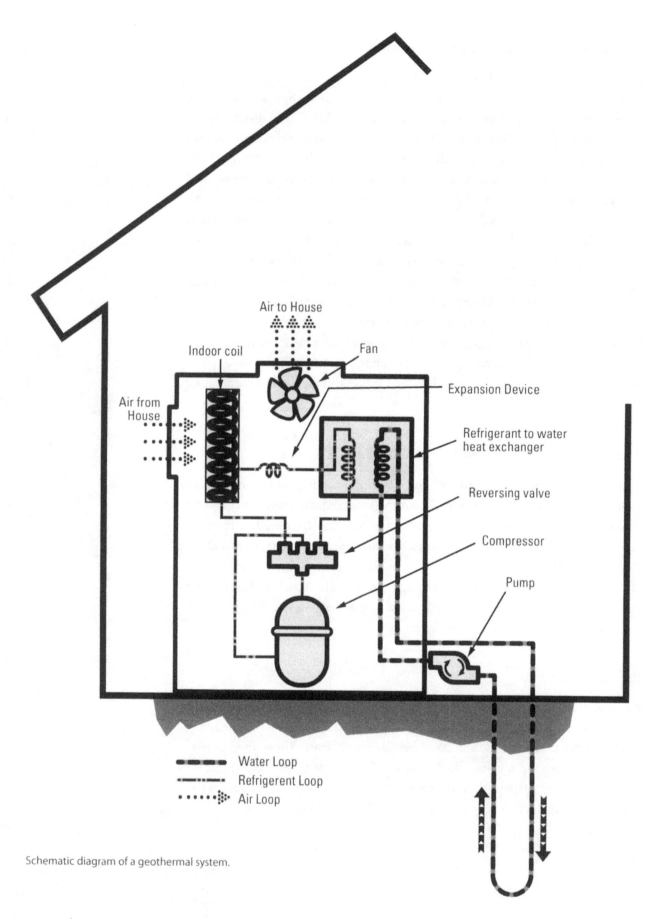

Air to House

Indoor coil

Fan

Air from House

Expansion Device

Refrigerant to water heat exchanger

Reversing valve

Compressor

Pump

Water Loop
Refrigerent Loop
Air Loop

Schematic diagram of a geothermal system.

Heat Pumps and Geothermal Systems

Another way to provide a complete HVAC system for your facility is with geothermal energy. This alternative energy system uses a pump to circulate water or glycol deep underground, where the fluid is cooled in summer and warmed in winter by the constant subsurface temperature. The heated or cooled fluid can be used with a forced air system or a radiant heat system (see the following section for more on radiant heat).

When paired with a forced air system, the geothermally heated or cooled fluid is supplied to heat pumps, which have the ability to both heat and cool the air. This air is then circulated (forced) through ducts by fans or air handlers.

In a radiant system, geothermally tempered fluid is still routed to heat pumps, but then it is circulated throughout the building's network of radiators. When used in this manner the primary function is to provide heat. If desired, cooling must be provided by other means. (For more background on alternative energy, see pages 75–78.)

Radiant Heat

A simple system typically found in older buildings consists of a boiler to heat water, which is distributed through pipes to radiators. A drawback to radiant heat is that it provides only heat, so cooling, humidity control, and filtration of particulates, if desired, will need to be provided by additional systems. Renovation of buildings with an old radiant heat system should include checking the pipes for soundness. If a radiant heat system is to be retained, options are to replace the old radiators with new, efficient ones or to add new individual controls to old radiators. Other situations may call for replacing the radiant system entirely with new technology.

In either case, attention should be paid to minimizing changes to a historic building's fabric and aesthetics. Consult *The Secretary of the Interior's Standards for Rehabilitation* (http://www.nps.gov/hps/tps/tax/rhb/index.htm) for guidance on accepted practices and approaches for historic buildings. Acting in accordance with these standards is particularly important for buildings in the National Register of Historic Places; failure to comply could jeopardize continued inclusion in the National Register.

Sustainability and Alternative Energy

Sustainability refers to the use, development, and conservation of energy and other natural resources so that the economic, social, and cultural needs of both present and future generations are met. Buildings that follow a green design

Cost and Capability of HVAC Systems

TYPE OF HVAC SYSTEM	RELATIVE FIRST COST	RELATIVE OPERATING & MAINTENANCE COST	RELATIVE MUSEUM ENVIRONMENTAL CONTROL CAPABILITY
Forced air—furnace and refrigeration	Low	Medium	Low
Forced air—air handling units and central boiler and chiller	High	High	High
Packaged HVAC with forced air	Medium	Medium	High
Fan coil with forced air	High	Medium	High
Geothermal with forced air or radiant	Very High	Operating: Medium Maintenance: High	Medium
Radiant heat	Low	Low	Low

employ the principles of sustainability. Interest in energy-efficient HVAC systems that reduce the dependence on fossil fuels has resulted in more installations that incorporate alternative energy sources for heating, cooling, and humidity control. These systems may use solar, geothermal, or wind energy or some combination thereof. Usually, alternative energy sources are not able to meet all of a facility's energy needs, but they supplement traditional energy sources to conserve both fuel and costs and reduce the carbon footprint.

All three types of alternative energy are no longer experimental but are proven technologies. That being said, not all equipment or installations are equal. As with systems using only traditional energy, an alternative system needs to use quality materials and be well designed. Alternative energy systems used in appropriate circumstances will function well and reduce purchased energy costs and hence lower annual operating expenses.

A drawback to alternative energy is that it generally has a greater initial cost than a system using traditional fuels—gas, oil, or purchased electricity. If you

are interested in an alternative energy system, research the life cycle of the proposed system and compare its replacement costs to a traditional system. To calculate the total cost for energy, factor the initial installation cost, the anticipated maintenance expenses, and the projected replacement cost into the true cost of a system.

Solar Power

Solar energy can be used in two ways. It can be used to produce electricity, usually as a means to reduce purchased electricity. (Only rarely can enough solar power be generated to completely replace purchased electricity.) Solar energy can also be used to heat water to supplement existing hot water systems, thereby also reducing the need for purchased energy.

Wind Energy

Wind generators are another way of producing electricity to reduce the amount of energy that needs to be purchased. While this technology is proven, it is not without pitfalls. First, proper positioning of wind turbines is critical and can be tricky. Second, equipment failures are not uncommon. The results of a study conducted in 2009–10 reported that five turbines installed on the roof of the Boston Museum of Science produced only 30 percent of the energy that had been projected. This was the result partly of variable wind patterns and partly of equipment problems with four of the five types of turbines that were installed (*Boston Globe,* February 9, 2011).

LEED

LEED is an acronym for Leadership in Energy and Environmental Design. This system of certification for green buildings strives to foster environmental stewardship using a framework that evaluates building and interior design and construction as well as building operations and maintenance. To be considered for a LEED award, you must submit an application to the U.S. Green Building Council. The council evaluates such things as sustainable sites, water efficiency, energy and atmosphere, materials and resources, and indoor environmental quality. Applications are rated with points that can place a project in one of four LEED categories: certified, silver, gold, or platinum.

While building to LEED certification standards will likely cost more than just building to meet local codes, LEED buildings are expected to recover those

Key to HVAC Success

When selecting an HVAC designer and installer—whether for a traditional or an alternative system—check experience and references. Be sure to employ an HVAC designer with a proven track record and installers with a history of satisfied customers. A good design can be thoroughly compromised by installation mistakes.

costs plus more in lower operational costs. Additional benefits include a healthier work environment, improved and reduced use of natural resources, and improved environmental stewardship in general. You can build to LEED standards without actually going through the formal application and certification, which is an added expense that a small organization might not be able to afford.

HVAC Operational Specifications

No matter which type of HVAC system you choose for your facility, you will need to specify various operating parameters for temperature, humidity, and air quality. These specifications are crucial for the design development of a successful museum HVAC system. If you are planning a large facility with multiple storage and exhibit spaces, your specifications may vary from space to space. Most small and medium-size museums, however, have fewer spaces and store their collections together in one room. That being the case, the environment in most facilities will be a compromise—one that is not ideal for any one type of object but at the same time is not damaging to any category or single item. Following are some general guidelines on the settings and standards appropriate to control the environment in your museum.

Temperature and Humidity Control

HVAC system control of temperature and humidity has two aspects: set points, which are the temperature and humidity that you require the HVAC system to achieve, and the amount of deviation allowable from the desired set points. Research conducted over the past fifteen years indicates that the constant temperature and humidity that for many years was considered the goal is not essential for long-term preservation of most museum collections. Experiments with a variety of materials have shown that most materials can withstand temperature and humidity fluctuations within the range of 55° to 74°F and 40 to 60 percent relative humidity (RH) without incurring any permanent damage. Some materials withstand a wider range in temperature, while others, for example many musical instruments, are highly sensitive to changes in humidity and do best with very narrow ranges.

In order to stay within these ranges, specifications for a system might, for example, be 65°F ± 4°F and 50 percent ± 10 percent RH. When damage does occur, it is generally either with extremely high or low levels of relative humidity or temperature or with large, rapid fluctuations in relative humidity.

There is still not universal agreement, however, over the acceptable limits for the rate of change. What has been agreed upon is that seasonal shifts to lower temperature and humidity during the winter and the cooler transitional seasons

may actually be advantageous for preservation while also having the benefit of reduced energy consumption.

To illustrate how seasonal shifts in set points might be beneficial for the collection, we can look at the Dew Point Calculator developed by researchers at the Image Permanence Institute. This interactive online tool can be applied to characterize the quality of storage environments. It uses temperature, humidity, and dew point to formulate an evaluation of the environment. It consists of a rating system (good, okay, risk) for four types of decay:

1. Natural, or chemical, decay of organic material (including wood, paper, plant and animal products, and plastics)
2. Mechanical damage of organic material
3. Mold growth
4. Metal corrosion

The Dew Point Calculator uses various calculations called *preservation metrics*. One of the metrics, the Preservation Index, is a number (1–9999) that is used to compare different conditions. For example, a storage room using HVAC settings of 65°F with an RH of 50 percent yields a preservation index of 56. Contrast that with settings of 60°F and an RH of 35 percent, yielding a preservation index of 110. By lowering the temperature 5°F and the RH 15 percent, the projected time before noticeable damage nearly doubles—a 96 percent improvement. The Dew Point Calculator has proven to be a very useful tool for planning or adjusting storage environments for archives, libraries, and museums. The Dew Point Calculator shown on page 80 is available for use online at http://www.dpcalc.

While it is relatively easy and inexpensive to maintain temperatures within the range of 62° to 73°F, maintaining humidity between 45 and 55 percent RH can be costly. Expanding the humidity range to 40 to 60 percent makes it more affordable. Adding moisture to the air (humidification) is not complicated and generally not terribly expensive. This is true for both new construction and re-habilitation of an existing facility. The exception to this is with older buildings that lack good vapor barriers, which are essential to prevent added moisture from escaping through walls and ceilings.

Dehumidification, however, is not as simple. Most of the expense in maintaining humidity levels comes from dehumidification. Initial equipment, maintenance, and energy consumption can all be expensive. If an HVAC system has difficulty maintaining set points, it is usually in the area of dehumidification. This is the aspect most frequently underdesigned. A design HVAC engineer should be able to tell you the difference in both the initial capital cost and the operating expense of a system with a functional specification of plus or minus 5 percent RH versus plus or minus 10 percent. This difference in expense is

Dew Point Calculator

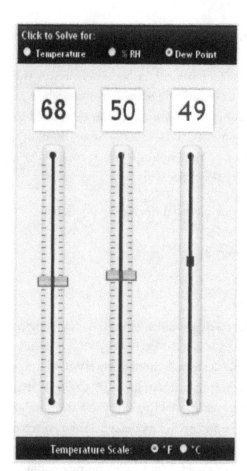

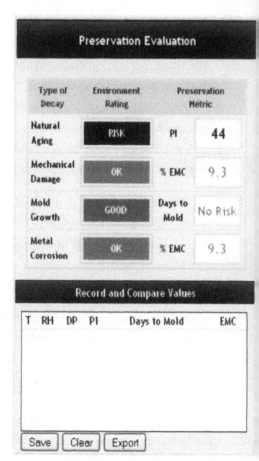

Key to Success: Which Cost Fits Your Operating Budget?

Ask your HVAC engineer to price the difference in operating expense for a relative humidity (RH) range of plus or minus 5 percent versus plus or minus 10 percent. You do not want to buy a system that offers a tighter range capacity if the monthly bills will be beyond your operating budget.

important. There is no point in paying for equipment with greater capacity if you cannot afford to operate it.

Digital controls and improved sensors are now the norm for HVAC control. With the advent of this new technology it is possible to program HVAC systems to different set points for different times of the year. A system can be programmed to gradually shift the temperature and humidity up or down over several weeks during the spring and fall. Almost all objects can accept gradual changes without damage. When damage does occur, it is generally either with extremely high or low levels of relative humidity or with large, rapid fluctuations in relative humidity. The following table gives suggestions for winter and summer set points and allowable fluctuations.

Suggested Settings with Seasonal Adjustments to Specify for HVAC Design				
SPACE	WINTER		SUMMER	
	Wide Range	Tight Range	Wide Range	Tight Range
Three-dimensional collections storage	62°F ± 4°F 50% ± 10% RH	62°F ± 4°F 45% ± 5% RH	68°F ± 4°F 50% ± 10% RH	68°F ± 4°F 55% ± 5% RH
Exhibit areas; Library reading room	70°F ± 4°F 50% ± 10% RH	70°F ± 4°F 45% ± 5% RH	70°F ± 4°F 50% ± 10% RH	70°F ±4°F 55% ± 5% RH
Paper-based and photo collections storage	60°F ± 4°F 40% ± 10% RH	60°F ± 4°F 35% ± 5% RH	65°F ± 4°F 50% ± 10% RH	65°F ± 4°F 55% ± 5% RH

Air Filtration

Filtering the air in a museum to remove dust and gaseous pollution is another important function of an HVAC system. Dust can soil objects such as paper, textiles, and leather and can abrade polished metal surfaces. Accumulation of dust can react with acidic atmospheric pollutants in a humid environment, damaging fragile glass and ceramic surfaces. Electrostatic air cleaners are not used in museum applications because they produce ozone, which is an oxidizing pollutant that will damage collections.

A forced air HVAC system includes filters to remove dust. A small system may use pleated filters much like those used in residential applications. Larger systems will often employ two sets of filters. Museum-quality particulate filtration generally requires this two-pass filtration system. The first set of filters, called *pre-filters*, removes the larger particulates using low-efficiency pleated filters. The second set will be either high-efficiency pleated or bag filters that remove smaller particles. When discussing dust filtration needs with your architect or an HVAC engineer, it is not enough to simply request a two-pass system; rather, you must specify the functional standards that you need to achieve the proper level of filtration.

How do you know what level of dust filtration you need, let alone the functional standard? The American Society of Heating, Refrigerating and Air-Conditioning Engineers (ASHRAE) has developed detailed standards and guidelines for indoor environments. The most recent version of the standard for

particulates (ASHRAE standard 52.2–2007) evaluates how well a filter removes particles ranging from 0.3 to 10 microns. This measure is expressed in the so-called minimum efficiency reporting value (MERV), which ranges on a scale of MERV 1 to MERV 16. The higher the MERV, the more effective the filter is at removing smaller particles. For a museum environment, you would want a MERV value of at least 14, preferably higher.

An older ASHRAE standard (52.1–1992) used the concept and measure called *atmospheric dust spot efficiency*. This is the rate at which a filter removes airborne dust particles that can soil interior surfaces and objects. To achieve appropriate air-quality standards for a museum environment, you would want at least 90 to 95 percent dust spot efficiency. The problem with this standard is that it does not accurately predict the filtering of particles smaller than 1.0 micron. The table below gives an idea of the wide range of particle sizes for various common substances.

To make sure you are covering the smallest particles when specifying environmental parameters for your HVAC system, use the newer, more comprehensive MERV ratings rather than the dust spot efficiency ratings. The table on page 83 shows both of these standards.

Gaseous pollutants, which cause chemical reactions, are another potential threat to collections. These gases speed deterioration of many kinds of collections, including paper, photographs, textiles, and objects with metal—especially silver, brass, copper, lead, and zinc. Gaseous contaminants may come from

Particle Sizes for Common Substances

PARTICLE	PARTICLE SIZE RANGE IN MICRONS
Face powder	0.1–30.0
Asbestos	0.7–90.0
Paint pigments	0.1–5.0
Humidifier	0.9–3.0
Copier toner	0.5–15.0
Insecticide dusts	0.5–10.0
Bacteria	0.3–60.0
Smoke from natural materials	0.01–0.1
Burning wood	0.2–3.0
Tobacco smoke	0.01–4.0
Typical atmospheric dust	0.001–30.0

Standards for Dust Filtration

ASHRAE STANDARD 52.2				ASHRAE STANDARD 52.1	APPLICATION GUIDELINES	
Particle Size Removal Efficiency Percent in Particle Size Range, µm				Dust-Spot Efficiency Percent	Particle Size and Typical Controlled Contaminant	Typical Air Filter/Cleaner Type
MERV						
	0.3–1	0.3–1	0.3–1			
16	>95	>95	>95	—	**0.3–1 µm**	**Bag Filters**
15	85–95	>90	>90	>95	All bacteria. Droplet nuclei (sneeze).	Nonsupported (flexible) microfine
14	75–85	>90	>90	90–95	Cooking oil. Most smoke.	fiberglass or synthetic
13	<75	>90	>90	80–90	Insecticide dust. Most face powder. Most paint pigments.	media, 12 to 36 inches deep.
12	-	>80	>90	70–75	**1–3 µm** Legionella. Humidifier dust. Lead dust. Milled flour. Auto emission particles.	**Pleated filters** Extended surface with cotton or polyester media or both, 1 to 6 inches thick.
					Nebulizer drops.	**Box filters** Rigid style cartridge, 6 to 12 inches deep.

This table is adapted from ANSI/ASHRAE Standard 52.2–2007

Maximum Levels for Gaseous Pollutants

GASEOUS POLLUTANT	MAXIMUM ACCEPTABLE LEVEL
Sulfur dioxide	Less than 10 micrograms per cubic meter ($\mu g/m^3$)
Oxides of nitrogen	Less than 10 micrograms per cubic meter ($\mu g/m^3$)
Ozone	Less than 25 micrograms per cubic meter ($\mu g/m^3$)

outside air; from off-gassing of construction, furnishing, or cleaning materials; from people; or even from the collections themselves. Contaminants of concern include sulfur dioxide (SO_2), oxides of nitrogen (NO_x), ozone (O_3), and volatile organic compounds (VOCs) such as formaldehyde and acetic acid. The table above presents the maximum levels commonly cited for the three main gaseous pollutants.

These criteria are difficult to monitor accurately at such low levels. The filters consist of canisters, or beds, of activated charcoal and specially treated pellets of potassium permanganate, which interact chemically with pollutants to remove them from the air stream. Both the initial installation of the filters and the on-going maintenance are expensive. A thorough analysis of need, cost, and benefit should be conducted before including gaseous pollution filtration in an HVAC system. To determine whether this expense is needed in your facility, conduct tests in your building or access local air-quality data to determine the levels of gaseous pollutants in your community. Every state and U.S. territory and a number of Native American tribes monitor and track air quality. Links to contact information for your state can be found at www.epa.gov/air/data/contslt.html.

Architectural Details for HVAC Control

Several architectural details need to be incorporated into your building's architectural design for the HVAC system to work well. These features will affect the stability of temperature, humidity levels, and air quality, all of which are critical for the preservation of your collections. During design development, be sure to discuss with your architect details in the building design and in specified materials that will affect the functioning and efficiency of your HVAC system. Also be sure to discuss the aesthetics of these details, particularly when renovating historic buildings. Changes to buildings listed in the National Register of Historic Places must be done in compliance with *The Secretary of the Interior's Standards for Rehabilitation* (http://www.nps.gov/hps/tps/tax/rhb/index.htm) in order not to jeopardize continued inclusion in the National Register.

General Facility Design Features

Outside or uncontrolled air needs to be buffered to keep it from entering a controlled zone. One way to achieve this is to create a vestibule at building entries. In cold climates, vestibules are a common feature in buildings. Closing the outer door before opening the inner door prevents uncontrolled outside air from directly entering the controlled space in the building. Vestibules can also be used inside a building, for example, to prevent relatively uncontrolled air from going directly into a low-temperature, low-humidity room, such as a storage room for film and photographs.

The overall layout, or floor plan, of the building also is important. Imagine a building with three types of zones: uncontrolled spaces, partially controlled spaces, and highly controlled spaces. Common sense dictates not placing a highly controlled space directly adjacent to an uncontrolled space. An HVAC system is much better able to maintain specified conditions when a highly controlled space is surrounded by partially controlled spaces. The latter buffers the highly controlled space from the extremes of the uncontrolled space. A storage room, for example, can open into a hallway rather than directly to the outside or into a big open uncontrolled space.

Large expanses of glass create several potential problems. Window walls will inevitably lead to heat loss during the winter and heat gain during the summer. This translates to increased energy consumption to compensate for increased heating and cooling loads. It is also possible that HVAC equipment would require upsizing (more money) in order to provide the increased capacity.

Design Details

The location of thermostats and humidistats also play a role in how well the environment in a space is controlled. Do not place these sensors near doors, where they would be subjected to short-term shifts in temperature and humidity. Also, do not place them directly in the path of air blowing from a duct. The stats should be placed in a central location where the temperature and humidity will be representative of the general conditions throughout the space.

In addition, pay attention to the location of the fresh-air intakes. Check to see that polluted air from sources such as idling buses or delivery trucks or from air being exhausted from the building will not likely be pulled into the building. Also, consider the role that prevailing winds may play in directing air near intakes.

Moisture barriers are another important detail to incorporate into your architectural plan. They will help maintain stable humidity levels. Humidity, and to some extent temperature, always tries to reach an equilibrium in adjacent spaces.

Moisture Control Methods and Materials

LOCATION	METHOD/MATERIAL
Interior walls	4–6 mil plastic sheeting inside the wall.
Ceiling	Foil-backed drop-ceiling tiles.
Cement floors and exposed walls	Vapor barrier paint.
Doors	High-quality seals and sweeps.
Exterior foundation walls	Vapor barrier material applied to outside of wall (e.g., bituminous coating or foil-backed panels between the wall and surrounding soil).
Exterior walls	4–6 mil plastic sheeting inside the wall. On inside of wall, insulation for cold, dry climates. On outside of wall, insulation for hot, humid climates.
Site with high aquifers or subterranean water flows	Drainage tiles, French drains, or other water diversion techniques.
Foundation	Soil graded to slope away from building. Drains and downspouts positioned to send water away from building.

Key Design Features for HVAC Control

- Plan a vestibule to buffer outside air from directly entering the building.
- Create a floor plan that surrounds spaces that need to be highly controlled with those that are at least partially controlled (e.g., other rooms and hallways).
- Avoid large expanses of glass.
- Place thermostats and humidistats away from drafts or locations where the air will not be representative of the space (i.e., doors and registers).
- Locate air intakes away both from outside sources of pollution and from prevailing winds.
- Carefully install moisture and vapor barriers in the walls, ceiling, and floor of all humidity-controlled spaces.

This means that water vapor (humidity) will always move from a space with a higher content to one that is lower. If a room that is regulated to keep humidity at 35 percent is adjacent to a hallway or an outside wall where the humidity is 50 or 60 percent, water vapor will want to migrate into the storage room. In order to minimize or prevent that, vapor barriers are needed. Vapor barriers, whether interior or exterior, must be installed carefully to avoid gaps that would compromise the integrity of the barrier. The table above presents some ways to ensure that moisture transmission will not imperil your efforts to maintain a good preservation environment throughout your building.

Lighting

A good lighting design is an essential part of any museum construction or renovation project. Just as temperature and humidity are a concern for the preservation of collections, so, too, is light. In fact, light is arguably the single greatest cause of deterioration in museum collections.

Light is one form of energy. Light striking and being reflected from an object is what enables us to see it. However, some of the light energy that strikes an object is absorbed and powers many of the chemical reactions that deteriorate light-sensitive objects. Deterioration from light is cumulative over the life of an object and is largely irreversible. This deterioration is visible as fading and yellowing, but it may also cause an item to lose strength and become brittle. Several factors determine the extent to which light causes damage:

- Material from which an object is made
- Condition of the object
- Type of light wavelength: ultraviolet, visible, or infrared
- Intensity of light
- Duration of exposure

Especially sensitive to light are objects made of organic material—documents and letters, photographs, textiles, clothing and accessories, works of art on paper. Yet these items, when featured in museum exhibits, spend a great deal of time exposed to light. So much time and money go into developing exhibits that they often remain up for years—far longer than is ideal for the preservation of the items displayed.

The design development process provides a golden opportunity to plan ideal or improved lighting throughout your facility. Like an architect who has never designed a museum and who does not understand the special requirements of a museum, a lighting designer also may not have direct experience with the special needs of lighting museum exhibit and storage spaces. If your architect or contractor does not have someone experienced in museum lighting design, consultants are available who can provide that specialized expertise. (For help on finding consultants, see the sidebar on page 44.) Note that it is the rare electrical engineer who is an accomplished lighting designer, no less a museum lighting designer.

The ideal interior design will vary depending on the intended use for each space, and it will take into account the needs for collections preservation and for visibility for visitors in the exhibit gallery and staff at their workstations throughout the building. In considering lighting options, keep in mind the types of objects in your collection. Your lighting can vary based on the preservation

Note the fading on the front of this Hopi basket that was exposed to light for too long. Consider both intensity and duration of exposure when designing exhibits.

needs of each artifact. Conservators generally think of objects as falling into three categories of sensitivity to light, as shown in the table on page 89.

Bear in mind, however, that the sensitivity and reaction of some material to light is variable. Some wood species are fairly light sensitive while others are less so. Also, light causes some wood species to fade (e.g., walnut, rosewood, and maple) and others to darken (e.g., cherry, poplar, and pine). In addition, the stains and finishes on wood objects can be light sensitive and over time fade, darken, crack, or flake.

Exposure

Controlling the exposure of collections to light is an important aspect of preservation in museums. Good lighting design can accomplish that by carefully controlling the total exposure of the collections to light. Most lighting designers have not had experience with lighting museum exhibits and are not versed in the sensitivity and needs of museum collections. You may need to educate them in the need to limit the exposure of collections to light.

The recommendations on page 90 relate to both measured intensity and the calculated duration of exposure, which is expressed in units of lux hours. *Lux* is the amount of visible light that you can actually see. It falls in the middle of the spectrum of light, while ultraviolet and infrared rays are at opposite ends of the spectrum. One lux equals approximately ten foot-candles, which is a more

Sensitivity to Light

	HIGH	MODERATE	LOW
TYPES OF OBJECTS AND MATERIALS	Paper (letters, documents, manuscripts, prints, drawings), gouache and watercolor paintings, wallpaper	Oil paintings	Stone
		Undyed leather, horn, bone, ivory	Metals
			Most ceramics
		Unupholstered furniture	Most glass
	Books	Wood (especially	
	cherry, pine, walnut)		
	Photographs		
	Textiles and clothing		
	Dyed leather, fur, feathers, baskets, and other organic material		

commonly used unit of expressing the intensity of light in the visible range.

Lux hours are calculated by multiplying the number of hours that an item is on exhibit by the intensity of visible light as measured in units of lux with a meter. Using this equation, the second table on page 90 reveals how length of exposure and intensity of exposure affect the overall exposure to light.

Another important factor in light exposure is ultraviolet (UV) light. The high energy of UV light makes it particularly harmful. Fortunately, its frequency is outside the range of human perception, so UV has no role in the visibility of objects. The recommendation is to filter UV light to a maximum level of ten microwatts

Changing Guidelines: Intensity versus Total Exposure to Light

For many years recommendations for the preservation of collections were discussed only in terms of the intensity of light. Guidelines for lighting levels were 50 lux (or five foot-candles) of light in the visible range for sensitive items, 150–200 lux for moderately sensitive material, 300 lux for low sensitivity items, and less than 75 microwatts/lumen for ultraviolet light. More recently the recommendations have changed to the concept of total exposure, which is comprised of intensity and duration.

Measuring Exposure to Light

LENGTH OF EXPOSURE	X	INTENSITY OF VISIBLE LIGHT	=	EXPOSURE LEVEL
50 hours		200 lux		10,000 lux hours
200 hours		50 lux		10,000 lux hours

Recommended Exposure Limits Based on Artifact Sensitivity

	HIGH SENSITIVITY	MODERATE SENSITIVITY	LOW SENSITIVITY
Recommended Maximum Exposure	50,000 lux hours/year	150,000–200,000 lux hours/year	200,000+ lux hours/year

Key to Success: Reduce Exposure to Light

Lighting plans can employ several methods to reduce 1) the amount of time objects are exposed to light, 2) the intensity of the exposure, and 3) the exposure to harmful UV:

- Use fewer bulbs.

- Select bulbs with lower wattage.

- Install museum-grade dimmer switches to set wattage at precisely determined levels.

- Turn off lights when not needed.

- Install occupancy sensors (motion detectors) to turn lights on and off.

- Filter all sources of UV light: windows, fluorescent bulbs, track lighting.

- Purchase UV filters that cover the full range of UV rays, 300–400 nanometers (not 300–380 nm).

(See "Track Lighting in Museums, Part 2" (www.mnhs.org/tracklighting2) for more information on dimmers, occupancy sensors, and UV filters.)

per lumen. Microwatts per lumen relate the absolute amount of UV in proportion to the amount of visible light that is present. Most commonly, UV in museum applications is measured using a Crawford UV meter, which is available from several companies.

So, how do you attain ideal exposure levels for your collection? In addition to reducing intensity by using fewer or lower-wattage bulbs, you can limit the amount of time that lights are on. Turning off lights when no one is in a room or exhibit gallery can be done manually or by using occupancy sensors (motion detectors), either of which can result in significant reduction of exposure. Filtering UV light at the source (both windows and light fixtures) also helps by minimizing damaging exposure. Glass UV filters are available for track lighting fixtures, tubular plastic filters are available for fluorescent bulbs, and UV filtering film can be applied to windows. Make sure that the UV filters you select filter the full range of UV light: 300 to 400 nanometers (nm). Some products on the market only filter from 300 to 380 nm, which is not sufficient for protecting museum collections.

Daylight

While some museums have windows and skylights in their galleries, there are several reasons why it is preferable not to allow daylight in exhibit spaces. It is difficult to properly light an item when intensity changes, not only through the seasons but also throughout the day due to the changing angle of the sun in relation to a fixed object. Windows in an exhibit gallery usually admit so much light that it is difficult if not impossible to achieve the light levels and controlled exposure over time that is necessary for protecting collections on exhibit. Windows in offices and artifact layout spaces also flood artifacts with excessive exposure, which has a distinct negative impact on their longevity. This caution also extends to entry areas if there is any chance they will be used to display collections.

Daylight is generally very bright, often around 10,000 lux, so bringing light levels down to recommended exposure levels can be difficult. Damage from daylight is exacerbated by a high degree of light in the ultraviolet range of the spectrum. Since UV is entirely unnecessary in order to see things, it should be filtered out, whether from daylight or artificial light, to eliminate it as a cause of deterioration.

Lighting Plans

Light is an important design development topic to cover in full detail not only with your architect but also with an electrician and a lighting specialist. The challenge in museums is to use only as much light of the right type as is necessary to make exhibits comfortably visible for visitors while protecting the collections from damage. The discussions you have with designers and electricians should address light from both natural (i.e., daylight) and artificial sources. These discussions should begin very early in the design process. It costs design time (i.e., money) for redesigning to eliminate excessive expanses of glass. Keep in mind the issues relating to exposure and the preservation of objects. Many architects like to design buildings that maximize natural light as much as possible. While this approach has merit for many kinds of architectural projects, daylight entering museum exhibit spaces from windows and skylights is problematic.

Exhibit Lighting

There are three basic approaches to lighting exhibit spaces. The first is to have general or overall lighting, which is often accomplished using fluorescent lights in the ceiling. This provides a fairly uniform but flat lighting over the entire room. The primary drawback to this method is that there are no highlights.

Overhead fluorescent fixtures create a flat, even light. The track lighting used here provides more light, which is not always needed, while adding virtually no visual impact.

Key to Success: Avoid Daylight in Exhibit Spaces

Work with your architect to design exhibit spaces without windows and skylights. Daylight is best avoided in galleries for several reasons:

- Properly lighting items is difficult because the intensity of daylight changes, not only through the seasons but also throughout the day.

- Daylight is generally very bright, with an intensity that is often around 10,000 lux.

- Windows admit so much light that it is very difficult to achieve the controlled intensity and exposure over time that is necessary to protect collections on exhibit.

- Daylight contains a high degree of UV light, which is very damaging to light-sensitive objects.

Artifacts and labels are lit at the same intensity as the floor, ceiling, and other surfaces that do not have artifacts, with the result that the artifacts and labels are not emphasized.

A second approach is to have lights inside exhibit cases. While this concentrates the light where the artifacts are, it has several shortcomings. First, the lights are generally attached to the top of the case, so the light is much brighter at the top than at the bottom. Second, shelves and objects that are high in the case create shadows on the items that are lower. Third, incandescent bulbs and fluorescent ballasts and bulbs generate heat that builds up in the cases, a situation that hastens the deterioration of many objects.

The third, and most desirable, approach is to highlight objects with accent lighting, which creates a more dramatic presentation. One of the most common and effective ways to accomplish this is with track lighting. A track lighting system is very flexible, since the fixtures can easily be added, removed, or moved. As exhibits change, this flexibility makes it possible to reconfigure lighting to accommodate different floor plans at virtually no cost. A mix of ambient and accent lighting concentrates viewers' focus on the objects and exhibit labels. A circuit for accent light fixtures with dimmers can aim a controlled intensity of light directly at sensitive objects. Another circuit can illuminate signage and provide dim ambient light throughout the gallery. Ambient light keeps the exhibit space from being too dark and unwelcoming to visitors. By using bulbs of varying wattages and beam spreads with dimmers on multiple circuits, the intensity of light can be adjusted to meet the need of each object and label. The use of occupancy sensors with each track lighting circuit significantly reduces the duration of light exposure on sensitive objects. Because it is so versatile, track lighting has become the standard that lighting designers recommend for museums. (See Further Reading for more information on track lighting.)

Storage Lighting

Architects may be unfamiliar with the topic of lighting in museum storage areas. These spaces should be dark except when someone is either retrieving or returning an item in storage. The goal is to provide lighting that discourages use of storage areas as workspaces. Most museums use incandescent or UV-filtered fluorescent lights to provide general lighting in storage. Some museums, however, use high-pressure sodium lights to great advantage. These lights emit no UV. Also, due to the wavelength of the light they emit, sodium lights distort many colors, so that you can neither see nor accurately describe the color of collections. Hence, the time people spend in storage, and therefore the amount of time that lights are on, tends to be minimized.

Occupancy sensors allow for a low level of light when no one is viewing an exhibit. Upon approach by a visitor, the system increases illumination to a comfortable viewing level. Thus, sensors both protect the artifact and save energy.

Exterior Lighting

Exterior lighting is an aspect of museum lighting that architects, electrical engineers, and commercial lighting designers will be more familiar with than lighting in exhibit and collection storage areas. Exterior lighting is used to illuminate the parking lot, the walkways, and the building itself. In addition to safety and security considerations, good exterior lighting provides an opportunity to increase public awareness of your institution and to enhance its image.

New Lighting Technologies

Recently, museums have begun to experiment with the use of fiberoptic lights, especially inside exhibit cases. While this has the advantage of not producing heat at the point of light emission, there is significant heat at the illuminator, the device that produces the light. This issue can be overcome when fiberoptics are designed to meet museum conservation requirements in terms of heat, color rendition, and the absence of UV. Fiberoptic lights can also reduce

energy consumption. Drawbacks include cost and the significant design expertise required to produce good results. (For a discussion of an application by the National Park Service, see "Lighting Museum Objects: Fiber Optics at Friendship Hill" by Larry Bowers, http://crm.cr.nps.gov/archive/16-5/16-5-4.pdf.)

Light emitting diode (LED) lighting is another newer technology that some museums are using. Early versions of LED provided poor color rendering, which limited its usefulness in many museum applications where accurate color is important. Recent advances have improved LED color rendering so that it is no longer necessarily too blue, or "cold." At present, LED lighting is not usually recommended for light-sensitive museum collections for several reasons. One of the most significant is that LED technology is developing at a rapid pace, and units purchased will quickly become obsolete. Another reason is that performance standards—such as color rendering, light output, and life cycle measurements—are not yet regulated for LED lighting. Further, LED lighting equipment and installation is fairly expensive. Hence, the payback period from reduced energy consumption is likely to be quite long if in fact it gets paid back entirely before the end of the useful life of the system. Before considering an

LED lighting system, be sure to compare the life cycle costs to existing mature lighting technology such as tungsten halogen.

Fire Suppression

With all the attention that goes into collection preservation during the design development process, no museum architectural plan is complete without a fire suppression system. Five basic types of fire suppression systems are available: wet pipe, dry pipe, dual-action, water mist, and inert gas. Each has advantages and disadvantages, and many facilities use more than one type of system. For example, a dual-action dry pipe system might be used in collections storage areas; a wet pipe system in office areas, meeting rooms, and other spaces where collections would not normally be located; and an inert gas system in the computer server room. While a standard wet pipe deluge system is most common for construction and the least expensive, other types of systems offer better protection for the collections use and storage areas of a museum. The pros and cons of each system are topics to discuss with your architect and mechanical engineer. The table on page 97 presents a summary of the five types of fire suppression systems.

Wet Pipe System

Probably the most common method of fire suppression in standard construction, the wet pipe system employs a series of pipes that are filled with water. When a fire occurs, the head on a heat sensor melts, sending a signal to discharge the water in the pipes. Its advantages are that it is the least expensive to install and probably the simplest of available technologies, but a wet pipe system also has some disadvantages. If a head were to break, you would have accidental discharge. Further, the initial water that is discharged is heavily laden with rust from the water having sat inside an iron pipe for a long time. This rusty water will stain many types of collections.

Dry Pipe System

A dry pipe system, on the other hand, has the same series of pipes, but they are not filled with water. When smoke or heat triggers an alarm, a valve opens and water fills the pipes and is then discharged from an open head. The major advantage of this system is that it reduces the possibility of an accidental soaking of collections. A disadvantage is that it takes more time than a wet pipe system to discharge. Also, unless the pipes are filled with an inert gas such as nitrogen, water from testing that remains in the pipes will cause rusting to the internal surfaces of the pipes.

Fire Suppression Systems

TYPE OF SYSTEM	PROS	CONS	COST
Wet pipe	Most common method in standard (non-museum) construction. Simple technology.	Broken heat-sensor head can cause accidental discharge. Initial discharge is rust laden, which stains many items.	Least expensive to install.
Dry pipe	Water is not stored in the pipes. Low risk of accidental soaking.	Takes longer to discharge. Some test water remains in pipes and causes them to rust.	More expensive than wet pipe system.
Dual-action	Can be used with either wet or dry system. Dual-sensor action reduces risk of accidental discharge.	More complicated technology.	More expensive than either wet or dry pipe system.
Water mist	Uses much less water (up to 100 times less). Good option for facilities with low water supply or low water pressure. Collections will not get as wet, making salvage easier. Easiest to retrofit into historical buildings.	Newer technology. Less commonly installed. Not universally code approved.	Can be more expensive than dual-action.
Inert gas (Novec 1230)	Uses no water. Has no negative environmental impact.	Recharging after accidental discharge is expensive. Generally limited to smaller spaces (a large storage room requires a very large amount of product).	Most expensive.

Dual-Action System

A dual-action system can be employed with either a wet pipe or a dry pipe system. As its name implies, it requires signals from more than one sensor (smoke or heat rise) to release the water into the pipes. The primary advantage to this system is that it reduces the possibility of an accidental discharge. Disadvantages are that it is a more complicated technology, which increases the risk of failure, and it is more expensive than a simple wet or dry pipe system.

Water Mist System

With a water mist system, the pipes are usually small in diameter and the heads, instead of discharging a heavy stream with large volumes of water, emit a fine mist that extinguishes the fire. The main advantage to this type of system is that it uses much less water in putting out the fire, so collections will not be as wet when salvage operations begin. Another advantage is that it employs smaller discharge heads than traditional water systems and much smaller piping, such as flexible copper tubing, and therefore can be retrofitted into a historic structure with little disruption to the building fabric and with low visual impact. Since this type of system uses as much as 100 times less water than wet and dry pipe systems, it can be installed as a self-contained system in locations where water supply or water pressure is limited by using tanks of water instead of water from a pressurized water main. Despite the reduced amount of water used, this is an effective fire suppression system. Drawbacks to a water mist system are that it is a newer technology that is much less commonly installed and it is not code approved in all jurisdictions.

Inert Gas

An inert gas system discharges a noncombustible gas that displaces the oxygen in the area of the fire, thereby preventing combustion. Early installations of this type of system used a proprietary gas called *Halon*. It was discovered, however, that the chemistry of Halon depletes the ozone layer in the atmosphere. As a result, Halon has been banned for further use. A number of replacement gases were formulated, but all had limitations and technical problems until 2002, when the 3M Company began selling a newly formulated product, Novec 1230, which has shown great promise. The product is shipped and stored as a nonhazardous liquid, but when it is discharged it almost immediately becomes a gas. It extinguishes flames by creating an 18°F drop in temperature. It is not ozone

depleting, has a negligible global warming potential, leaves no residue, and is nontoxic and nonlethal at normal use concentrations. Novec 1230 has been installed at several cultural institutions in the United States, including buildings at the Library of Congress and the Smithsonian Institution.

Security

Building security is an integral part of museum construction design that is addressed in both schematic design and design development. Any museum, rural as much as urban, faces threats to security. A new or remodeled building provides an opportunity to evaluate security needs, which include the safety of people as well as property.

Planning for Security

While the major threat to security is theft of artifacts and equipment, other threats are those to personal safety, vandalism, arson, and other criminal activity. No one can stop a determined person from breaking in or challenging security, but any organization—particularly one that is updating its facility—can take steps to minimize security risks.

First, those responsible for security should be involved in planning prior to the schematic design. Doing so will save money in both project expenses and future operating costs.

Second, avoid security salespeople, who are well trained as sales experts. Instead, consult with a qualified security specialist who has the ability to evaluate all existing conditions and recommend solutions as opposed to someone whose job it is to just sell equipment. Individuals certified by the International Foundation for Cultural Property Protection (http://www.ifcpp.org/recommended-service-providers/associate-members-and-recommended-service-providers) can evaluate without the conflict of interest in having to sell particular products.

Finally, protecting the facility requires attention to a combination of architectural details and procedures and policies that work in concert with each other. Whether high- or low-technology systems and equipment are employed, people implement and execute the procedures, monitor the building, and maintain the equipment. Procedures and technology are tools for people to use to effectively secure their facilities. Continuous and relentless attention by staff and volunteers is essential, along with the technology tools used.

Access and Security

As you design, add onto, or remodel your building, you will need to balance security measures with the need for public access. Some security measures may be in the form of physical barriers to impede movement, while others may be far less noticeable.

If barriers are chosen, you will need to carefully consider the message that each sends. Landscaping is one type of barrier and a major aspect of security. Distance from roads can be an aspect of security and needs to be incorporated into landscape design. Choice of vegetation should enhance the aesthetics of your building and the visitor experience but must not provide cover for those seeking to hide. Two of the more effective and inexpensive exterior barriers to aid security are thorn bushes and motion-activated lighting. Neither barrier hinders people who visit for legitimate reasons.

If exterior cameras are added, they should be able to operate well in your weather conditions and have high-definition digital capabilities that operate in low light with an auto iris, which automatically adapts to changes in light levels. Keep in mind that your organization will need to consult with legal counsel about proper wording for twenty-four-hour monitoring notices.

Exterior doors, windows, skylights, and locks are obvious vulnerabilities that call for high-quality materials and workmanship augmented by an electronic alarm system. Vegetation outside of access points should be well trimmed to avoid trapping moisture and promoting conditions that could compromise materials. Again, vegetation should not help conceal someone seeking unauthorized entry.

Safety for People

The safety of people within your building is your first priority. Whether your museum is in a large urban setting, a suburb, or a rural area, the most likely place for assaults and illicit drug transactions will be your restroom. Those engaged in these activities do travel, and though they may not commit a crime the first time they visit, their first visit may serve to assess the situation for use at a later date. Isolated facilities that have insufficient security become excellent targets; thus, your organization has a responsibility to thoroughly consider threats and take adequate measures to address potential problems.

Since restrooms tend to be a frequent site for graffiti and crime, moderate-sized to larger facilities should consider a design for the restrooms that does not have doors. Those intent on committing undesirable behavior may be deterred if they are unable to conceal what they are doing. Smaller facilities on more limited budgets might instead consider locking the doors to the restroom(s) and requiring prospective users to obtain a key on a large stick from the information desk, which should be continuously monitored with a camera. Restrooms without doors will require more space because of the meandering access required for privacy. Do not place cameras in the restroom or trained on the restroom entrance.

In the event of an emergency, many jurisdictions require that public buildings, including museums, have what is called an *area of refuge*. People are able to flee to this specialized and secure room with its own ventilation, dedicated communication, and electrical systems when escape is not otherwise possible in order to await rescue by emergency responders. In addition to fires and natural disasters, the area of refuge can also be used to escape from those seeking to harm people. Your architect will determine whether this type of room is required for your facility.

If your facility will have only a limited number of staff, sightlines from the reception desk or from an office are essential. The key is to have clear sightlines to the entire monitored space. Routes for random patrols through the facility should help those who are simultaneously staffing reception to return to their post quickly. Place communication systems for staff contact throughout the building to aid staff in supporting one another and in protecting themselves and the public should emergencies arise.

Loss Prevention

If safety of people is your first priority, then loss prevention is your second. Since your mission is to preserve and make history accessible, you are obligated to preserve your collections by preventing the theft of objects, which would deprive future generations of access to those collections. Work with your architect to build theft prevention measures into the design of your facility.

Many design features can help deter theft. For example, build collections storage to have restricted access and no windows. For exhibits, create small barriers, such as the rise of a movable platform (even without a railing). Design a lighting system with spotlights to highlight objects. Plan exhibit cases or areas that are out of reach for items small enough to put in pockets or bags. For a research library, controlled access and lockers for coats, bags, and purses are essential. With only one way in and out (and proper emergency egress), patrons will pass a checkpoint, which is often a desk with excellent sightlines to monitor the researchers' room and archival storage.

Finally, consider interior finishes as another low-tech security measure to prevent loss and undesirable activity. Noticeable contrasts between the public and non-public areas in your museum are a comparatively low-cost measure to enhance security. Nicer finishes in the public areas, versus a more utilitarian look in behind-the-scenes areas, will send a signal to visitors who may inadvertently wander into a secure area.

Technology

The technology for electronic monitoring systems continues to improve, and prices have become more affordable for small museums. You will want to select a system that can expand with the needs of the facility over time. When choosing an electronic monitoring system, adopt a nonproprietary system that can be repaired by multiple contractors. This will save money in the long run. Plan and budget for constant monitoring seven days per week, twenty-four hours a day, regardless of the type of system.

The selection of type, the placement, and the installation of system components are generally left to a qualified security specialist, but the building committee needs to participate actively in all aspects of this process. Hardwiring and backup batteries for the security system should be installed during the construction of your facility. While a wireless alarm system is acceptable, it can be somewhat more vulnerable to technical problems than a hardwired system with battery backup. A wireless system, ideally, should be an Internet provider–based system so that captured data are stored off-site. Regardless of the type of technology, the security system should be zoned to maximize flexible use of the facility (like zoning for HVAC control), so that some areas of the building can be used when other areas are closed.

In addition to monitoring access to the building, the alarm system needs to guard access points to collections storage rooms, to the exhibit gallery, and to the library, all of which may be closed during hours when the building is used for non-museum functions. Individual exhibit cases that contain items of especially high importance might also be alarmed. A variety of alarm sensors can be selected to detect unauthorized access. These include

- Contact sensors for the opening of locked doors or windows
- Sensors for glass breakage
- Motion detectors
- Cameras

Select cameras with the capacity for high-definition digital images and instant retrieval of images. If cameras are not passively recording all of the time, then each must be on motion-activated switches. Much like lighting sensors,

motion-activated switches for cameras can save money and resources over time. Beware, however, of any salesperson who boasts that a camera system's video analysis can eliminate the need for a person to monitor the system. And, although rare, beware of those selling passive infrared cameras, which do not meet modern security standards.

As you determine the placement of each piece of equipment, keep in mind the access for maintenance. Failure to follow the manufacturer's directions for cleaning, testing, and other periodic tasks can leave your organization vulnerable to liability. Create a plan to maintain and replace components at the time the building is commissioned. (See page 127 for more on building commissioning.)

Choice of Materials

During the design development phase, every material that will be used in constructing and finishing your project is detailed in lists called *specifications* and *schedules*. (See appendix 2 for a detailed explanation of specifications and schedules.) The selection of room finishes, furniture, and cabinetry affect not just the look and the cost of your facility; materials also can have significant environmental impact on your collections. Paints and other finishes, adhesives, wood, and floor coverings are some of the materials with the potential to harm collections over time. Many substances emit gases called *volatile organic compounds* (VOCs), which will damage museum collections. VOCs include formaldehyde and formic and acetic acids. The following sections and tables address some materials, but many others exist that could also have adverse effects. A number of large museums and conservation centers routinely evaluate materials prior to use in exhibit construction and in storage. One source that lists materials and products that have been tested and evaluated is available online at http://www.mnhs.org/materialstested.

Technological Keys to a Successful Security System

In selecting an electronic security system, consider the following:

- Participate actively throughout planning and installation.
- Choose a nonproprietary system that can be repaired by multiple contractors.
- Install hardwiring (with battery backup) for the system during construction of your facility.
- For a wireless system, select an Internet-based system so that data is stored off-site.
- Zone the system to create flexibility for different areas.
- Place alarms at internal as well as external access points.
- Select specific sensors for appropriate circumstances.
- Avoid passive infrared cameras.
- Follow the equipment manufacturer's requirements for maintenance.
- Monitor all components of the system on a regular basis.
- Budget for continuous electronic monitoring and maintenance.

Wood

The effects of wood vary depending on the type, age, and seasoning of the wood. An important consideration is the potential for wood to off-gas VOCs, which can have harmful effects for both people and collections. Most woods are acidic and some—including oak, western red cedar, and Douglas fir—emit significant

VOCs. Any wood with an acidity lower than pH5 can emit significant VOCs. Among these woods are larch, yellow pine, hemlock, red maple, red mahogany, and teak. Cork is another product to avoid, as it is one of the variants of oak. Better choices are basswood, poplar, mahogany, and walnut, all of which should be air dried and well seasoned. In general, green or newly cut wood and wood with knots are poor choices.

Engineered wood products such as particleboard and plywood can also be harmful. Many manufacturers of these products use resin binders that emit formaldehyde, which not only is unhealthy for people but also can cause corrosion of metal and the growth of damaging white crystals on stone, shell, ceramics, and glass. When it comes to wood sheet products, particleboard, chipboard, Masonite, and interior-grade plywood are the worst choices. Better choices are American Plywood Association (APA) graded and stamped exterior-grade plywood and Medite II. Medite II is a medium density fiberboard (MDF) sheet manufactured by the Sierra Pine Company that has the general appearance of a particleboard but is quite different because it is certified not to contain formaldehyde. Medite II is a good choice to replace plywood and particleboard for shelving, museum storage cabinets, exhibit cases, and other display furniture or mounts.

Surface Finishes

Paint and other surfaces finishes are also materials that can affect the preservation of your collections. The film-forming resin of many paints, including interior latex, is made from polyvinyl acetate (PVA), which is a poor choice for museums. Both the vinyl and acetate components can off-gas during curing and later as well, which can damage museum collections. Other poor choices are oil-based paint and oil-modified paint, such as alkyds and vinyl acrylics. A 100 percent acrylic (non-vinyl) resin often found in exterior paint is a stable compound when dry and is a much better choice for museum, library, and archives applications.

In order to establish that a paint or other finish for walls, floors, ceilings, and storage and exhibit furniture are safe for collections use and storage spaces, a number of characteristics and qualities of the finish need to be determined. The questions listed on page 106 should be sent to the manufacturer of each surface finish proposed for use. The manufacturers' responses will help you determine which products are appropriate to use in your museum.

Note that finishes—including paint, varnish, polyurethane, and lacquer—will not prevent off-gassing of VOCs from wood or manufactured wood products. These finishes are all semi-permeable, which means that they will allow VOCs to gradually pass through them into the interiors of exhibit cases, storage cabinets, and rooms.

Materials Selection

TYPE OF MATERIAL	PRODUCTS TO AVOID	SOME ACCEPTABLE PRODUCTS
Wood	oak, western red cedar, Douglas fir, larch, yellow pine, hemlock, red maple, red mahogany, sweet chestnut, teak, cork, green or newly cut wood, wood with knots	air dried and well seasoned: basswood, poplar, mahogany, walnut
Wood products	particleboard, chipboard, Masonite®, interior-grade plywood	exterior-grade plywood that has been graded and stamped by the American Plywood Association (APA); Medite II (medium density fiberboard)
Paint	polyvinyl acetate (PVA) based paint (e.g., interior latex); oil-based paint; alkyds; vinyl acrylics	100% acrylic (non-vinyl) latex
Other finishes	polyurethanes, oil-based varnishes; latex varnishes; tung oil	shellac; two-part epoxy; Camger™ 1–175
Plastics	polyvinyl chloride; polyvinylidene chloride	Plexiglas®; Lucite®; polycarbonate; polyethylene; polyester; polypropylene; polystyrene

Determining the Safety of Surface Finishes

QUESTION FOR MANUFACTURER	DESIRED RESPONSE
1. What is the film-forming resin?	The film-forming resin component of paint or other finishes should be a stable, inert material such as acrylic, polyester, or two-component epoxy. Polyvinyl acetate (PVA) or vinyl-toluated alkyds should not be part of the formulation due to inherently unstable chemistry, which will result in harmful vapors being released over time.
2. What is the method of cure?	In most cases cure will be by evaporation. Some finishes, such as powdercoat finishes and epoxies, cure by polymerization. Generally, epoxies have two components that require accurate mixing of the two ingredients to obtain complete cure.
3. How long does it take to achieve 100 percent cure?	The length of time to cure, especially for finishes curing by evaporation, is affected by ambient temperature and humidity, so responses to this question may need to be adjusted. Ask the manufacturer for guidelines on how to adjust cure time to your specific climate conditions.
4. What is the procedure to test for 100 percent cure?	Any response is acceptable as long as you are able to follow the procedure recommended.
5. Do any free radicals remain in the polymer film after it is cured?	No
6. Are there any volatile materials in the film after cure?	No
7. Are there any long-chain drying oils in the formulation?	No
8. Are there any biocides in the formulation, such as formaldehyde?	No
9. Do any of the components (including colorants) contain sulfur-bearing compounds?	No

Off-Gassing Time

Any paint or finish that is applied should be allowed to fully dry and cure before introducing any artifacts. Follow the manufacturers' recommendations for curing. One good guideline to follow is that if you can smell the finish then it is still off-gassing. For a painted wood cabinet, for example, close the doors to the cabinet and allow it to sit overnight. In the morning, open the doors and smell the interior. If there is any odor, the paint or finish needs additional curing time.

Flooring is another potential source of off-gassing pollution that can damage collections. Carpet and vinyl flooring can be particularly problematic. Plasticizers in vinyl flooring and in base molding off-gas, as do fiber surface coatings, the backing of carpets, and the adhesive used to attach them to the floor. The same rule applies here as with paint: if you can smell anything, then the off-gassing is not complete and more time and aeration are needed.

Other materials with the potential to emit problematic gasses are polyether and polyurethane foams, vinyl and rubber door gaskets, vinyl and polyurethane ceiling acoustic treatments, urea-formaldehyde adhesive, and some silicone caulking and adhesive that emit potentially damaging chemicals.

Polyvinyl chloride (PVC) plastic, which is a concern because it emits hydrogen chloride and plasticizers, probably cannot be entirely eliminated since many pipes are PVC. Perhaps the best strategy is to alert your architect, HVAC engineer, or designer of your concern and make sure that no pipes (except for fire suppression) are routed through or above artifact use and storage areas.

> ### Key to Off-Gassing Success
>
> Include time in your project schedule for off-gassing of all materials. If you can smell anything, then more time is needed to complete the curing and off-gassing process.

Completing the Design Development Phase

The comprehensive technical information presented in this chapter along with the design development process discussed in chapter 4 will enable the building committee and architect to detail the systems needed for a museum environment. In chapter 6 you will learn how the architect will use the completed design development drawings, specifications, and schedules to develop the final construction documents that will be used to bid the project for construction.

Construction Documents and the Bid Process

Before construction begins on your project, the architect pulls together the final design instructions into a package called *constructions documents,* or CDs for short. Prospective general contractors will then use the construction documents to bid the cost they would charge to build the facility.

Construction Documents

When you signed off at the end of design development, you effectively completed the project design. While assembling the construction documents, your architect will compile all the technical information that needs to be added to the design development documents. Notes on the floor plans, cross-sections, and elevations will explain every necessary technical detail. In fact, these are called *detail drawings,* or details. Your architect will also create a project manual that includes final versions of all the specifications and schedules compiled during design development. Together, the construction drawings and the project manual form the finalized construction documents. This is the package that general contractors will be given to bid on the project, and contractors will use the CDs to construct the building.

During this phase, all of the sets of drawings—architectural, structural, electrical, mechanical, landscape—are coordinated. Due to the interrelationship of components and systems, making a significant alteration in one item will have a ripple effect, causing changes in other areas. But if you have done careful work during the previous phases, you will avoid the complicated, time-consuming, and costly effort that changes can generate.

Code and Permit Review

When construction documents are nearly complete, your architect sends a set to the relevant government officials for building code and permit review. Local regulations require that you obtain one or more permits before you can begin building. To qualify for a construction permit, the construction documents must comply with fire, safety, and construction codes. Your architect will incorporate

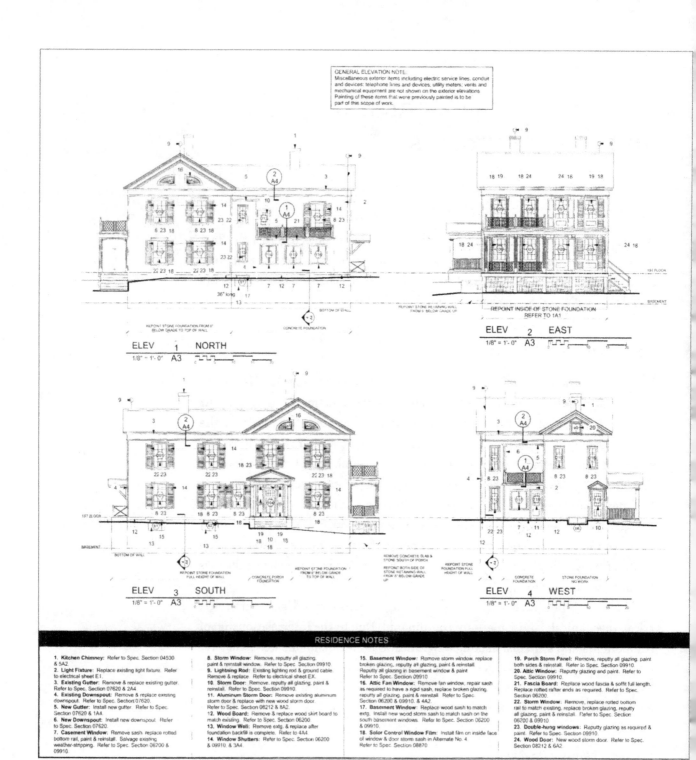

Sample elevation drawings.

into the construction documents any changes that are required as a result of these reviews. This is all part of the process of finalizing the construction documents.

Final Review

It is essential that the building committee reviews the construction documents very carefully. You will get only what is in these documents. If a storage room door, for example, was intended to be nine feet high but it is listed in the schedule as seven feet, you will get a seven-foot-high door. If you really needed a nine-foot door it will cost more to correct this later than if you had caught the mistake. No matter what the height of the ceiling, you will not be able to move your tallest items as you had planned. If a room was supposed to have an electronic keycard reader for controlled access but it is not in the drawings, you will pay a premium to have one installed later.

The importance of this final review cannot be overemphasized. If you are not confident that your organization has the ability to review the drawings, schedules, and specifications yourselves, you may elect to hire a consultant to assist you. A professional construction manager, an independent engineer, or some other specialized consultant would be a good candidate. Although hiring a consultant will add a little to the project cost, catching mistakes or omissions now versus discovering them during construction can spare you the agony of having to choose between a significant cost increase or forgoing an important functional detail.

> **Key to Error-Free Construction Documents**
>
> Take the time necessary to complete a thorough review of all construction documents to ensure that every detail is correct. If your organization cannot do this review effectively, hire a professional construction manager or an independent engineer for this task. (For help on finding consultants, see the sidebar on page 44.)

The Bid Process

With construction documents in hand, the next step is determining what the project will actually cost to build. Your architect will prepare a solicitation consisting of construction documents, instructions to bidders, and the formal request for bids.

Legal Issues and Warranties

Other parts of the solicitation address legal issues related to contracting (bonding, minority hiring, permits, etc.) and terms for such things as payment schedule, reporting and documentation, punch lists, the timetable for substantial

completion of the project, and warranties. Your institution's legal counsel must review the solicitation package before it goes out to ensure compliance with applicable laws and regulations.

Your solicitation should also specify that a construction contract must include a general warranty for the building. Contractors generally stipulate anywhere between one and three years for the general warranty. You should require it to cover at least four complete seasons after the building is fully occupied and operational. This four-season rule of thumb is important because the HVAC system will not be fully tested until all of the collections have been moved in and the building is open to the public. Maintaining temperature and humidity in an empty building is entirely different from maintaining specified conditions under a full load.

Certain components of the building may carry their own, longer warranty. One example is roofing, which is frequently warranted for ten or fifteen years. Other examples are boilers, compressors, and furnaces. The importance of having complete warranty information, organized and accessible, is self-explanatory.

> ### Key to General Warranty Success
>
> Make sure your bid solicitation requires a general construction warranty to last a minimum of one full year after your building is fully occupied and operational. Only under these conditions will your HVAC system be put to the full test while still under warranty, which is when you want to be sure it maintains the required temperature and humidity specifications.

Bid Solicitation

If required by either internal policy or government funders, the person who prepares the bid package for your institution publishes an announcement in a newspaper of record requesting competitive bids for the project and noting when and where to pick up bid documents, who to contact, and when bids will be due. If you do need to publish a request for bids, you may also be required to repeat the announcement several times over a period of weeks. You may also invite specific construction companies to bid on the project by sending them the solicitation package. By announcing your request for bids in a newspaper of record you offer many companies an opportunity to learn about and bid on the project. The more bids you receive, the more choices you have. Regardless of whether you publish your request, your goal should be to broadcast your project as widely as possible. Having more bids to choose from will give you a better chance of obtaining a bid from a reputable firm that satisfies all of your requirements, including your budget.

> ### Key to Successful Bid Soliciting
>
> Broadcast your request for bids as widely as possible. The more bids you receive, the more choices you have and the better your chance of success.

Keep in mind that the timing of a request for bids may affect the response you get. If there are many projects either under construction or about to commence in your area, fewer companies may be interested in bidding since they are already busy. This may affect not only the number of bids received but also the price that companies are willing to charge. Companies eager for business are generally willing to work for a slightly smaller profit margin.

Another cost factor relates to variability in the price of materials. During a construction boom, for example, the price of steel and lumber may go up because of decreased availability and market pressure. Although bidding a project during a boom time in construction may push prices up, waiting to bid may also result in higher prices due to inflation.

> ### Factors that Affect Bidding
>
> ▶ Availability of general contractors
> ▶ Cost of construction materials
> ▶ Inflation
> ▶ Supply and demand for materials

Bid Acceptance

Bids are accepted until the date and time specified in the bid documents, at which point a representative from your organization opens the bids and records the results. Your architect and a group of people representing your museum (which may include the board of directors, the building committee, and financial and legal advisors) will then evaluate the bids. The first task is to determine if the bids meet all of the criteria set forth in the solicitation. If all goes well, you are able to choose a successful bid. You may base your selection on the lowest price or the best value, which may be a combination of factors such as price, experience, and proximity.

If, however, the bids received exceed your budget or if none meet the required conditions, you may reject all of them. If none meet all of your criteria, you will need to evaluate if all of the shortcomings are essential or if you can accept the differences. If all of the criteria must be completely met, you will need to repeat the solicitation process. If all bids continue to exceed your budget, you will need to either raise more money or reduce the project to match available funding.

Once you have selected a general contractor, the next step is to have your organization's legal counsel prepare and execute contracts, which bind the bidder not only to the cost in the bid but also to all of the specifications and conditions set forth in the solicitation. Having achieved the milestone of selecting a contractor, you are finally ready to move on to construction.

Construction

During construction, the building committee's role will be different than it was in the earlier planning phases. The lead shifts from you and the designer to the general contractor. Nevertheless, you still have important oversight responsibilities. Understanding the stages of construction will help prepare you for those times during construction when you may be required to make important decisions.

Construction Management

Construction projects are generally complex undertakings involving many people: multiple vendors, contractors, and subcontractors, each with their own schedule, level of involvement, responsibility, and allegiance. A mix of professionals, tradespeople, and unskilled workers will be involved, and their schedules need to mesh smoothly for the project to be completed on time and on budget. This requires management. Who will do this? Will you hire someone or have a staff person manage the project?

On some projects the general contractor assumes management responsibilities. Sometimes the building committee, museum staff, or board does it. In some instances an individual or firm specializing in construction management is hired. The term *construction manager* applies to any of these scenarios.

Schedule Management

Schedule management is a crucial aspect of construction management. Subcontractors need to begin work in the correct sequence. Materials have to arrive at the right time, and the right people have to be there in order to install them. When there is a delay, the manager may have to coordinate with multiple contractors and vendors to adjust schedules.

Budget and Quality Management

Ensuring that your project stays within budget and representing your institution to ensure quality control are other important roles of the construction manager. He or she sees that the materials and equipment specified in the construction

documents are delivered in the quantity and quality called for and properly installed or, in more candid terms, that you get what you pay for. The construction manager oversees quality control while the work is done. For example, is the specified number of coats of paint or waterproofing being applied? Is the concrete the type and grade specified and is it being poured within the acceptable range of temperature so that it will cure properly? Budget and quality management also involves advising and keeping track of change orders, contingency funds, value engineering, and deduct- and add-alternates.

Change Orders

Any change requested after contracts for the project have been signed requires a change order. Examples of changes include adding or moving a door or wall, replacing or upgrading a material or a piece of equipment, or correcting an error that was discovered in the plans. A change order is like a separate purchase agreement and incurs an additional cost. Since the work will not get bid but will be undertaken by the firm already under contract at a price that they alone determine, change orders tend to be expensive. They need to be kept to a minimum for the project to stay within budget. When changes need to be made, a professional construction manager may be able to suggest less expensive alternatives; part of a construction manager's job is to analyze costs so that the solution selected is also the most cost effective.

Contingency Fund

As the name suggests, a contingency fund is money allocated in the budget for unanticipated costs. An example of an unanticipated cost might be the removal and disposal of a previously unknown hazardous material discovered on the site. Or you may find that you must substitute a piece of equipment that costs more than the one originally specified because the original has been discontinued. You may unexpectedly discover a design error, which will require a change order to correct. Or you might decide to implement an add-alternate (see page 117). Another function of the construction manager is to advise the building committee when it is appropriate or essential to use contingency funds.

Value Engineering

When a project goes over budget, a change is necessary to make up this additional expense. *Value engineering* is a euphemistic term to describe the process either of reducing quality or quantity or of eliminating something altogether to reduce cost. Since many, if not most, architects and engineers have little

experience with museums, libraries, and archives and the nuances of how they function, you need to bring your knowledge to bear, pay close attention, and be very involved in the process of value engineering. Architects and engineers will make recommendations for value engineering, but your organization is responsible for making the decision to accept or reject. When the importance of a function is poorly understood or undervalued, you may get design changes that have a negative effect on the preservation of collections, on collections management, or on the ability to effectively present information to visitors.

For example, a value engineering decision may downgrade particulate (dust) filters in a building's HVAC system to reduce costs both in initial installation and in operating expenses. This change, however, will lead to a more rapid accumulation of dust on exhibits and on collections in storage. Dusty exhibits reflect poorly on your institution, and dust can damage artifacts over the long term. The consequence is that unless more staff time is devoted to cleaning exhibits and collections in storage, your organization's artifacts and image will suffer. An experienced construction manager will be able to advise you about the ramifications of different options, including which would be the most cost effective with the least reduction in quality or function.

Deduct- and Add-Alternates

Alternates are individually priced items included in the bid documents but not in the base contract. Deduct-alternates provide options for reducing the cost of the project if the bids come back higher than anticipated. Add-alternates are the opposite. They are items or options that are not in the base bid and that can be put into the project if the bids come back lower than anticipated. Also, if you find as construction progresses that some of the contingency funds will not be needed, you can implement an add-alternate. This allows you to add something to the project that has already been designed and bid on and that only requires a change order to authorize.

Keys to Successful Value Engineering

- Remember that you understand museum operations better than your various contractors.

- Be very involved in the process of value engineering.

- Base any value engineering decision not just on project budget but also on the long-term impact on collections and operations (i.e., staff time required for maintenance).

- Ask your construction manager for guidance on the ramifications of various choices.

Site Preparation

The first step in actual construction is site preparation. Site prep entails any required demolition and excavation. During excavation, the organic topsoil is removed and stockpiled for later use. Any contaminated or otherwise inadequate soil will be removed, replaced, and compacted to specifications. Depending on the site and building design, excavation may require grading the site, digging

Depending on the needs of your project, site preparation can include any or all of the following steps:

- ▶ Demolition
- ▶ Land excavation
- ▶ Hazardous waste disposal
- ▶ Groundwater and surface water diversion
- ▶ Surveyor markings for roads, building, and utilities

trenches for footings, or excavating the entire footprint of the building for basements, sub-basements, and tunnels for utilities that may run under the building.

Discovery of contaminated soil or other hazardous materials during excavation or demolition is likely to require hazardous waste disposal, which will use some of the contingency budget. Surveyors will mark locations for the building, for roadways and curbs, and for utilities (water, gas, electrical, and sewer).

Work on stormwater drainage and erosion control begins during site preparation. If the presence of a high water table was established during earlier test borings or is discovered during site prep and excavation, it may be necessary to provide for water diversion to keep the lowest level of the building dry. The design and implementation of water diversion, if not planned and budgeted for earlier, will use some of the contingency budget at this point.

Structural Work

Following site preparation, work on the structural components of the building begins. Structural work includes footings, foundation, beams, columns and joists for floor and roof support, and stairwell construction. This is the basic framework of the building around which the rest of the structure will be fabricated.

In addition to ensuring that the details of floor and wall connections follow the plans, the construction manager should also solicit inspections to verify that welding of steel and curing of concrete adhere to specifications. Over time, substandard welds or improperly mixed or cured concrete will result in cracks and weakness in the underlying structure of the building. While structural failure is rare, cracks in

Structural Components

- ▶ Footings
- ▶ Foundation
- ▶ Beams
- ▶ Support columns and joists
- ▶ Stairwell construction

Key to Structural Success

Correct installation of structural elements is critical to prevent future problems. Your construction manager is responsible for inspections to check that all work meets the plans and specifications in your construction documents. You want to be sure that your building will not develop problems later that would have been avoided with more rigorous oversight.

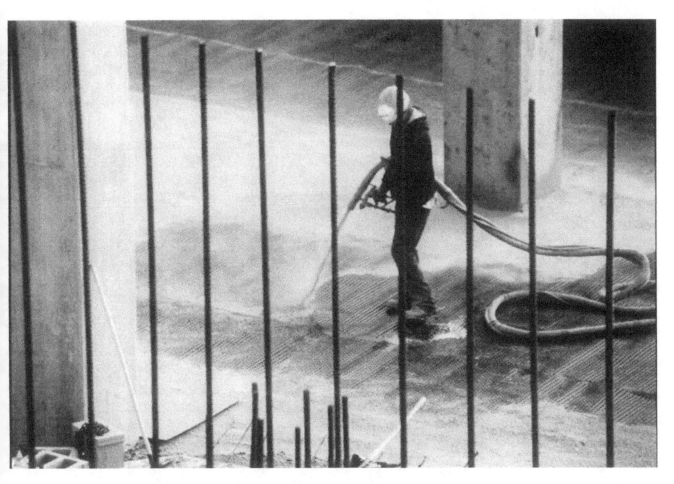

Construction of a building or addition proceeds in stages. Note here that the columns are in place and structural rebar installed; next, the concrete floor is being poured.

concrete, for example, can allow water to seep from one floor into rooms below. Since storage is almost always in the basement, any water leak will inevitably find its way down into collections storage spaces—obviously not a desirable outcome.

Architectural, Electrical, and Mechanical Installation

Once the basic structural work is completed, work begins on installation of the architectural elements, the electrical wiring, and the mechanical equipment. Exterior and interior walls are constructed, as is the roof. While some plumbing and electrical items may be in the floors, the majority will be installed in the walls and under the ceilings. During this phase of construction, the level of activity picks up. Walls, windows, and doors are being installed. The components of the HVAC system are installed, usually at the same time that the electrical system is going in. Myriad details need to be checked and inspected to ensure that what is built is what you approved when you signed off on the construction

After walls are roughed in, electrical, plumbing, and mechanical system components are installed.

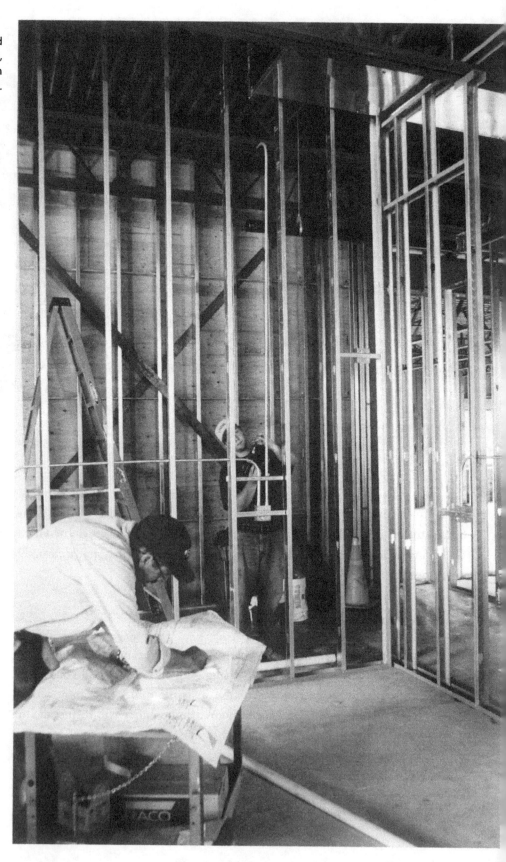

BUILDING MUSEUMS: A HANDBOOK

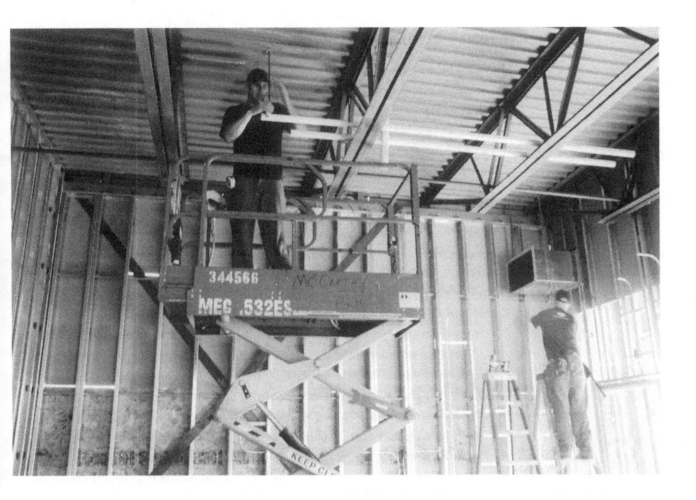

documents. Having a construction manager to represent your institution is particularly important during this phase. As someone experienced in all aspects of construction, an on-site construction manager will ensure that materials, equipment, and the methods and quality of their installation meet the specifications and standards of the construction documents.

Architectural, Electrical, and Mechanical Components

- ▶ Walls
- ▶ Roof
- ▶ Ceilings
- ▶ Plumbing
- ▶ Electrical wiring
- ▶ HVAC
- ▶ Windows
- ▶ Doors

Key to Success: Construction Management

Having a construction manager to oversee the installation of architectural, electrical, and mechanical systems is crucial to ensure that all specifications and standards are met during this very busy stage.

Applying Finishes and Purging Chemicals

After the framework for the walls is complete with plumbing and electrical wiring in place, drywall is installed. Once that happens, painting and other finishing can begin. This step in the construction process is an important milestone. As finishes cure, they emit chemicals, a process called *off-gassing,* which can cause significant damage to collections. Paint, carpet, and vinyl flooring are all sources of chemicals called *volatile organic compounds,* or VOCs. Other products that off-gas VOCs include wood products—especially plywood and particleboard—adhesives, and sealants. In most cases, you can smell these chemicals in the air. These materials should be installed as early as possible to allow a purging period for them to off-gas and be exhausted from the building prior to moving in collections. EPA studies have shown that it can take as long as a year for VOCs to off-gas, with the majority occurring during the first six months. With this knowledge and good planning you can build time for off-gassing into your construction and move-in schedule. This off-gassing time is called a *purge period.*

It is often possible for the construction manager to negotiate with the contractor to schedule the installation of materials that will off-gas VOCs to happen earlier in the process than might normally be done in construction. For example, collections storage usually ends up in the basement. Since the basement has to be built first, this area can be painted well before other areas so that it can begin off-gassing sooner rather than later. In many cases, it is also possible to operate the HVAC air handlers earlier than might normally be done to help exhaust chemicals that can damage collections. During a purge period, the air handlers in the uncompleted building are adjusted to bring in the maximum amount of outside, fresh air that the system can deliver. Some newer systems are capable of bringing in 100 percent outside air and not recirculating any inside air. If this is done (even if not 100 percent outside air) for a period of one to six months prior to moving collections into the building, potential damage to collections from these chemicals can be minimized.

> ### Key to Success: Purging Chemicals
>
> Minimize damage to your collections by planning time for a purge period, during which VOCs from paint and other finishes can off-gas before you move collections into their new space. During the purge period, ask the contractor to adjust the HVAC air handlers to bring in as much fresh air as possible. Allow from one to six months for your purge period—the longer the better.

Substantial Completion

Substantial completion is another milestone in the construction process. Once your contractor has informed you that the building is largely done, you will schedule a *walk through* (also known as a prefinal, or preliminary, inspection). The HVAC system is fully functional, all equipment built into the building has

been installed, and a local government agency or building department has issued a certificate of occupancy. This certifies that your building complies with applicable building codes and other laws and can be occupied.

The walk through is a thorough inspection of the building that you, your architect, and your construction manager will do with the contractor. During this inspection you will identify remaining work items to be completed and corrections that need to be made. The list of these items is called a *punch list.*

Upon substantial completion, as before at the end of each design phase, you will sign off to indicate acceptance of the work completed to this point in time. Once you have signed off on substantial completion, your organization assumes responsibility for utilities, maintenance, security, and insurance and may begin to move in.

Punch List

During the walk through, and continuing after moving into your new facility, you will inevitably discover details from construction that still need attention. Some things may not work; others may not function properly or may have been installed incorrectly or poorly. You may even discover some things that were never installed. A punch list includes all of these items. In accordance with your bid documents, your general contractor will be required by contract to address punch list items before you sign off on final completion of the project and make final payment.

Your bid documents stipulate the length of time allowed to address the punch list. Usually this timeframe is generous—often twelve months. You want sufficient time to resolve all issues, especially since problems are not always immediately evident. During this time, items can continue to be added to the punch list as they arise. At agreed-upon time intervals, a designated person gives the general contractor an updated punch list so that corrections can be made.

Key to Punch List Success

Make sure your general construction contract specifies plenty of time—preferably one year—to address your punch list. Some problems do not surface immediately; as you discover details from construction that still need attention, add these items to the list.

Documentation

Documentation of construction is important for record keeping. Your construction manager can be charged with preparing regular reports that become a record of work accomplished, meetings held, decisions made (e.g., authorization of a change order), and who made them. This documentation can also include a photographic record of construction. The construction manager can also be responsible for collecting as-built drawings and operating and equipment manuals. If you do not hire a construction manager, you will need to assign the task of documentation to a staff or board member.

As-Built Drawings

An important aspect of documentation is keeping a record of any deviation from the construction documents. The construction documents show what your architect and engineers designed. The building actually constructed inevitably differs slightly from the design. For example, during construction it may be discovered that a pipe cannot be installed in the location specified in the design because a duct or column is in the way. When situations like that occur, changes are made to remedy the problem. Having a record of those changes facilitates ease of repair or other work in the future. The architect and engineers compile this record by creating a set of as-built drawings to show how the building was actually constructed.

Operating and Equipment Manuals

An operations manual is another form of documentation. It consists of written instructions for the operation and maintenance of every piece of equipment installed in the building. The manual includes instructions for running and servicing all HVAC equipment (such as boilers, air handlers, filtration devices); pumps (water, air, vacuum); variable air volume units; refrigeration equipment; fire suppression systems; and elevators. It also includes instructions for myriad small items, such as the components of the security system, mechanical door openers, and kitchen equipment. Some instructions come in the form of a manual from an equipment manufacturer. For equipment that is part of a custom-designed system, the design engineer will need to write specific operating procedures, possibly in consultation with the manufacturer(s).

Construction is the last significant phase in your building project. As you move in, you will start to use what you created—the new, rehabilitated, or renovated building. The completed building is not the end but a means to implement your vision to better serve the public and the collections.

Moving Day and Beyond

Signing off on substantial completion is an exciting milestone in a construction project. After months of disruption, your building is finally ready for full operation. Now you can turn your attention to the details of orchestrating the move-in, planning a grand opening celebration, and adjusting to new surroundings.

Meanwhile, your construction manager will oversee the steps to final completion of the project—finishing the last details and corrections. When these steps are complete, your general contractor and construction manager will walk you through the new facility for a final inspection. Before you sign off on final completion of your project, everything on the punch list must be resolved or you will likely be paying another vendor to remedy the problem. Once you agree that everything is finished, you will sign off on final completion and pay your last bill to the general contractor. Congratulations—you are done!

Orchestrating the Move

Moving is an activity that will require significant planning. Part of this planning involves estimating how many boxes, truckloads, hours, and people will be needed to move the collections. You will need to think about the time needed to pack and unpack items and how much time it will take to transport everything. Part of the planning takes into account potential delays that would cause you to postpone moving in. For example, the weather (rain, snow, cold) may not cooperate, or the new shelves and cabinets you ordered might not be delivered or installed on time.

The planning for when to move should also accommodate a sufficient purge period for VOCs. If you are planning to move before off-gassing is complete, how can you phase the move so that collections of glass, ceramics, and stone go first, while vulnerable materials like photos, silver, paper, and textiles are saved for the end?

Part of the planning also includes thinking about people—not just how many but also who is going to do the packing, transporting, and unpacking. You may plan to do it yourself or to hire professional movers. You may plan to share the work. Each option has advantages and disadvantages.

If you involve new people, will you have to train them? If training is needed, who will do that and how much time will it take? Options for adding help are

Professional movers
with staff supervision
handle treasured
objects safely.

hiring temporary employees or adding additional volunteers, whether they
be from the general community, from service organizations (e.g., Boy or Girl
Scouts, 4H, Lions), or from community service alternative sentencing programs.

Certainly, cost is a factor in the decision about who will do the work of
moving. Hiring professional movers is expensive, but they provide moving
equipment—carts, dollies, trucks, blankets, etc. While using volunteers is eco-
nomical, it is time consuming to recruit, train, and supervise them. There is no
single correct answer. You will need to figure out the cost versus time balance
that works best for your organization.

Moving can be an opportunity to accomplish tasks that may have been on
your to-do list. Since moving entails handling every item, you have an ideal
opportunity to conduct a thorough inventory, to photograph the collection,
and possibly to identify items that are candidates for deaccessioning from the
collection.

Obviously, your collections will be temporarily inaccessible, either partially or entirely, during the period when they are being packed, moved, and unpacked. How long should you plan to remain closed? Some institutions feel very strongly that public access to the collections should be interrupted as little as possible. You may move the library collection while maintaining public access to the museum collections. Once the library is accessible again, then the museum collections are moved. Other institutions have chosen to close access well before the move, so that staff can concentrate on inventory and packing, and re-open only when everything has been relocated in its new setting. In some cases, such as renovation, you may have been forced to close during construction and can re-open only when construction is complete and your collections are back in place.

Building Commissioning

Building commissioning is a process wherein an independent specialist is hired to check the performance of a building to ensure that it is functioning as designed. Building commissioning is focused primarily on the HVAC system, but the process includes testing of all systems to ensure that they have been installed properly and are functioning as intended. This work takes place after you have fully occupied the building, when all systems are operating under what is expected to be normal circumstances. The building commissioner will identify systems or items that are not operating properly. When a minor adjustment is all that is needed, the building commissioner can fix the problem while assessing performance. For bigger problems, the commissioner will propose corrections and call in your general contractor or a subcontractor to do the work.

> The definition from ASHRAE (American Society of Heating, Refrigerating and Air-Conditioning Engineers) Guideline 1 "The HVAC Commissioning Process" is ". . . the process of ensuring that systems are designed, installed, functionally tested, and capable of being operated and maintained to perform in conformity with the design intent."

Key to Moving Success: Careful Planning

Moving requires coordinating numerous details. Here are some questions to consider as you plan:

- How much time will you need to pack and unpack items?

- Will you add time for a thorough inventory or to photograph your collections while packing or unpacking?

- How much time will you need to transport everything?

- When will you move, and what potential delays might cause you to postpone the move?

- If off-gassing is not complete, how can you phase the move to have the least negative effect?

- Who will pack, transport, and unpack?

- If you will use new people, will they require training? If so, who will do this and how long will it take?

- If you will use new people, will this cost money? If so, how does this fit your budget?

- What is the appropriate balance between the expense of hiring full-service movers and the time spent if you rely entirely on museum personnel?

- Will you need to be partially or completely closed during the move? If so, how long?

Celebrating with a Grand Opening

When your facility is ready to show to the public, mark the completion of your project with a grand opening. This is a time for celebration and an opportunity to thank everyone who worked on the project. The occasion can be elaborate or simple, depending on your budget and what is most appropriate for your community. You may consider having multiple special events for members, for donors, and for people or groups who made special contributions to the project.

Do not forget to thank the construction workers and others who helped with your project. Most of them will not have worked on a museum before. The project will have been a novelty for them, and they will have faced requirements and solutions that are different from most jobs. Generally, crews get invested in the job, so an invitation to a special event for them to bring their families to see and show off what they have accomplished is a special way to say thank you and to acknowledge their contribution.

Give lots of thought and care to the public opening. This is your opportunity to show what you have accomplished not just to past visitors but also to the new audiences you talked about when you began planning the project. Have a formal ribbon cutting that involves civic officials, significant donors, and important stakeholders. Schedule building tours that include behind-the-scenes storage areas for archives and artifacts, that showcase new programs, and that provide entertainment. Make sure this event generates the positive feelings in your community that you need to make the new facility a success.

Adjusting to New Surroundings

Just as the design and construction phases of your project interrupted the usual patterns of staff and volunteers, so, too, will adjusting to the new surroundings.

After the long and intensive effort required to build or renovate a museum, holding a grand opening provides a celebratory welcome for volunteers, staff, supporters, and the community.

Long-time staff and volunteers have been used to doing things a certain way prior to the project. Some will see the new environment as an opportunity to improve operations and respond with renewed energy and enthusiasm. Others may have difficulty adjusting. It is not uncommon after a move to have a certain amount of turnover.

You can minimize the loss of experienced and productive staff and volunteers by preparing them for what it will be like in the new setting. Involve them in designing the new procedures needed for the programs in the new building. Help everyone understand and expect that you will have more visitors and researchers. Continue to monitor how staff and volunteers are adjusting and work with those who may need help.

Museum Spaces Organized by Function

1. Visitor Services

 a. Visitor drop-off area
 b. Lobby and reception area
 c. Auditorium
 d. Caterer's kitchen/Lunchroom
 e. Retail sales area
 – Merchandise storeroom(s)
 f. Coatrooms
 g. Office
 h. Restrooms

2. Research Library and Archival Collections

 a. Reception
 b. Coatroom
 c. Microform study room
 d. Library reading room
 e. Collections storage
 f. Collections holding and processing
 g. Photocopy room
 h. Office

3. Exhibits

 a. Galleries
 – Gallery, permanent
 – Gallery, changing
 – Orientation room
 – Storeroom, exhibit furniture
 – Storeroom, exhibit housekeeping
 – Restrooms
 b. Exhibit Development
 – Office
 – Layout room
 – Workshop
 – Supplies storage

4. Museum Collections

 a. Office
 b. Storage
 – 3-D collections
 – Storage, 2-D, prints, drawings, posters, framed art
 – Storeroom, storage supplies
 – Storeroom, office, storage, and exhibit furniture
 c. Holding rooms
 – Collections temporary holding room, clean
 – Pest control/mold treatment room
 d. Workroom

5. Education

a. Reception area
b. Workroom
c. Classroom(s)
d. Office(s)
e. Storage, supplies
f. Storage, teaching aids, props
g. Restrooms

6. Administrative Support

a. Offices
b. Workroom
c. Boardroom
d. Conference room
e. Clerical support rooms or spaces
f. Photocopy room
g. File room
h. Storeroom, supplies
i. Lunchroom or lounge
j. Restrooms
k. Coatrooms or lockers
l. Information Technology
 – Computer server rooms
 – Offices
 – Workrooms for hardware support
 – Equipment storage

7. Shipping and Receiving

a. Loading dock
b. Holding rooms
c. Mail and supplies room

8. Building Support Services

a. Janitors' sink and supplies storage
b. Telecommunications equipment room
c. Elevator
 – Shaft
 – Equipment room
d. HVAC equipment room
e. Main electrical room
f. Supplies storerooms
g. Office
h. Security office
i. Groundskeeping equipment storage

Reading Blueprints, Specifications, and Schedules

In order to review the documents that are prepared for your building you will need to know how to read blueprints and understand specifications and schedules. *Blueprint* is a generic term used for all drawings used in a project. Blueprints show where and in some cases how everything is to be built. Blueprints include references to the products and materials that are detailed in specifications and schedules. *Specifications* are the technical description for every product and material that will be used in your project. *Schedules* are lists that are organized by room number for a product or material, for example light fixtures, that will be used in your building. Schedules are sometimes listed within your specifications and other times they may appear directly on drawings.

Being able to read and understand these documents is critical because anything that does not appear in the construction drawings, specifications, and schedules *does not exist for the building.* Examples of items you may be expecting that might not have been added to the specifications list include special doors, a ten-foot ceiling clearance from the loading dock into collections processing and storage areas, a floor drain in a specific room, and an access for changing lights in the twenty-five-foot-high ceiling. Any item not included in the construction documents will not be included in the bids and will not be built or installed. Conversely, anything that you did not want (for example, PVA-based paint in collections areas, water pipes in or above collections use or storage areas) that is in the drawings or specifications will be constructed, used, or installed.

The construction documents are your last chance to review what is to be built before the project is bid. Once you approve and sign off on the construction documents, you have accepted each and every detail on the plans and in the specifications. You can make changes later through a change order, but this will use time and energy and cost more (sometimes significantly more) than if you caught an error or made a desired change before signing off on construction documents.

Reviewing plans, schedules, and specifications can be daunting; however, the expression "the devil is in the details" could not be more applicable than in the case of reviewing these documents. The more careful and thorough your review, and the more detailed and specific the comments that go back to your design

team (the architects and engineers), the closer your building will be in function as well as appearance to that which you have envisioned.

Drawings are organized into standard sets, as follows:

- Site plan
- Landscape
- Demolition
- Structural
- Architectural
- Mechanical
- Electrical

Every sheet of each set is labeled with a letter to signify the set of drawings to which it belongs—S for site plan, L for landscape, etc.—and a page number. Each set contains several sheets, and each sheet is assigned a number signifying the type of drawing and the particular view of the facility. Some numbers will be duplicated across sets. For example, A1.11 shows the architect's design for all or a part of the building, while E1.11 shows the electrical plan for the same area. These numbers are usually in the bottom right-hand corner of each sheet.

Each set contains four types of drawings—plan, elevation, section, and detail. Each type uses a large array of unique graphic symbols.

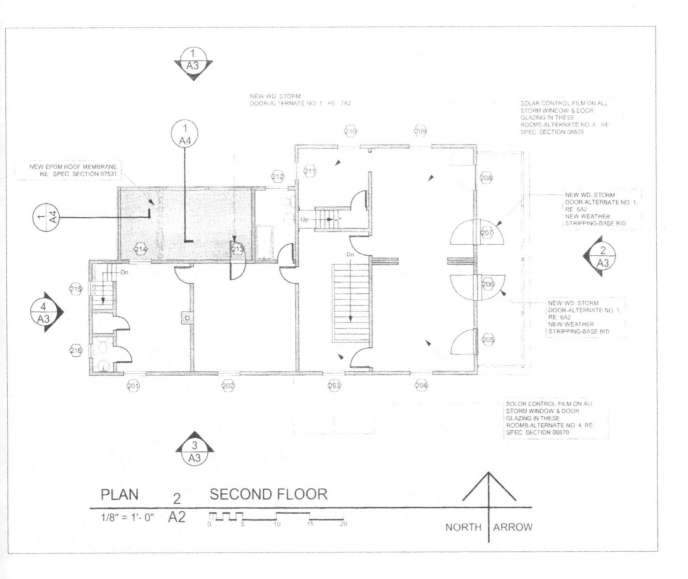

Plan Drawings

A *plan* or *plan view* is a drawing of a horizontal surface (see above). While usually it is a bird's-eye view from above, it can also be a view looking up at a ceiling, which is called a *reflected ceiling plan*. Plans show walls, doors, windows, and built-in equipment (e.g., sinks, counters, storage cabinets). A plan can be of the entire floor of a building or a more detailed drawing of a room or two. Plans contain graphic symbols that refer to other drawings (elevations, sections, or details) and to types of equipment or materials. Each set of plans (e.g., architectural design development plans or mechanical construction documents) should have a list of symbols and abbreviations used in that set.

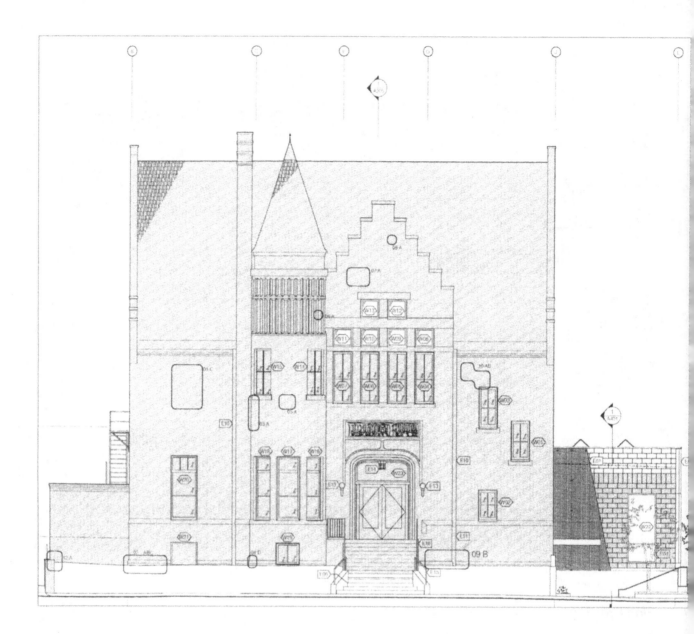

Elevation Drawings

An elevation is a drawing that shows a vertical feature (see above). Elevations are flat, or nonperspective, drawings showing the appearance of each side of a building—front, sides, and rear—or interior features such as built-in cabinets and architectural details.

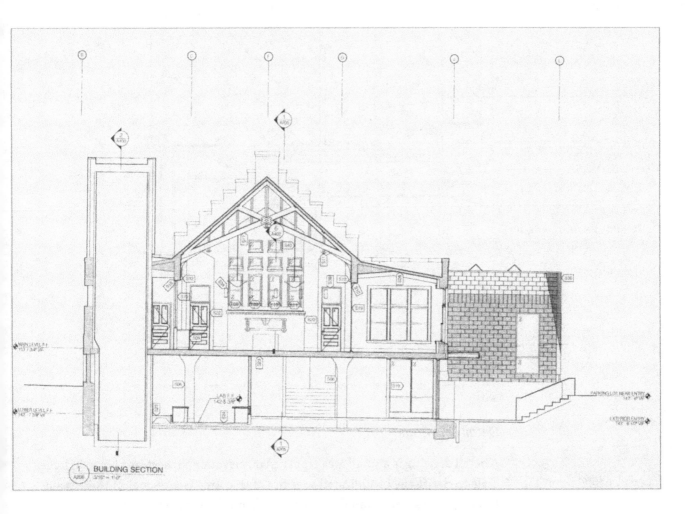

Section Drawings

A section, or section view, is a slice or cross-section of a building or part of a building that is intended to clarify certain details of construction (see above).

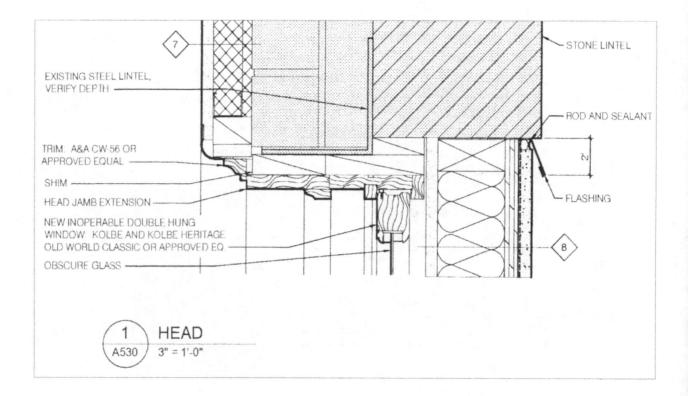

EXISTING STEEL LINTEL,
VERIFY DEPTH

TRIM. A&A CW-56 OR
APPROVED EQUAL

SHIM

HEAD JAMB EXTENSION

NEW INOPERABLE DOUBLE HUNG
WINDOW: KOLBE AND KOLBE HERITAGE
OLD WORLD CLASSIC OR APPROVED EQ.

OBSCURE GLASS

STONE LINTEL

ROD AND SEALANT

FLASHING

1 HEAD
A530 3" = 1'-0"

Detail Drawings

A detail drawing is a small area from a plan, elevation, or section shown in large scale to clarify the complicated specifics of that area (see above). If there is sufficient space, some detail drawings may be on the same sheet as a plan, elevation, or section. If, however, that sheet would become too crowded with the addition of detail drawings, then the sheet will have a graphic symbol for finding each separate detail drawing. Often, the symbol is a circle with a horizontal line through the center containing numbers unique to each detail.

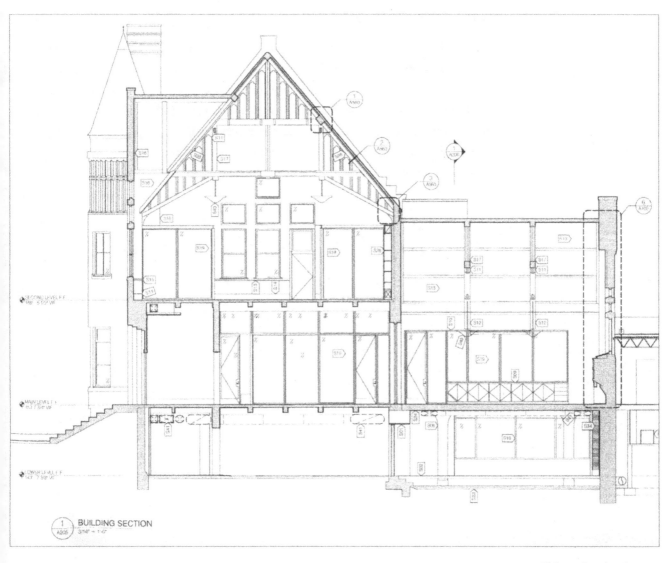

BUILDING SECTION
1
A205 3/16" = 1'-0"

This section drawing
calls out several detail
drawings.

Symbols and Abbreviations

Drawings—whether plans, details, elevations, or sections—contain a vast array of symbols and abbreviations. They condense an enormous amount of information, but they are not intuitive and are totally incomprehensible to a layperson. The following pages present a guide to the symbols and abbreviations that you may see on architectural, mechanical, and electrical drawings. If, as is usually the case, your architect gives you drawings that do not contain a key to symbols and abbreviations, you can use these pages to decipher your drawings.

ARCHITECTURAL SYMBOLS

CONCETE WALL

CONCETE BLOCK WALL

BRICK WALL

DOOR

EXTERIOR DOOR

SLIDING DOOR

BIFOLD DOOR

DOUBLE DOOR

STAIRS

BATH TUB

URINAL

TOILET

MOP SINK

UTILITY SINK

ARCHITECTURAL SYMBOLS

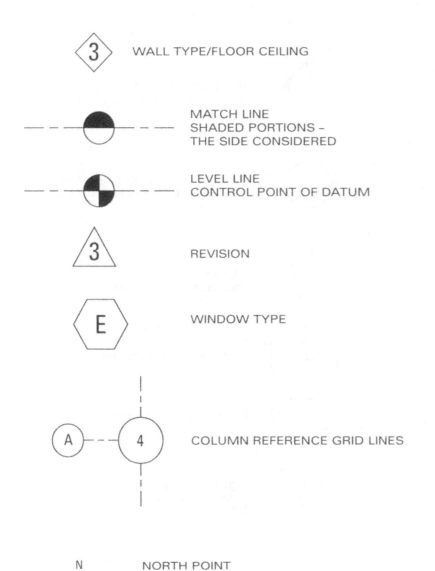

WALL TYPE/FLOOR CEILING

MATCH LINE
SHADED PORTIONS –
THE SIDE CONSIDERED

LEVEL LINE
CONTROL POINT OF DATUM

REVISION

WINDOW TYPE

COLUMN REFERENCE GRID LINES

NORTH POINT
TO BE PLACED ON EACH
FLOOR PLAN, GENERALLY
IN LOWER RIGHT HAND
CORNER OF DRAWING

ARCHITECTURAL SYMBOLS

BUILDING SECTION
REFERENCE DRAWING NUMBER

WALL SECTION OR ELEVATION
REFERENCE DRAWING NUMBER

DETAIL
REFERENCE DRAWING NUMBER

1302

ROOM/SPACE NUMBER

354

EQUIPMENT NUMBER

DOOR NUMBER
(IF MORE THAN ONE DOOR PER ROOM
SUBSCRIPT LETTERS ARE USED)

ARCHITECTURAL SYMBOLS

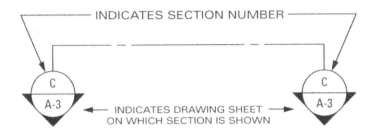

INDICATES SECTION NUMBER

INDICATES DRAWING SHEET ON WHICH SECTION IS SHOWN

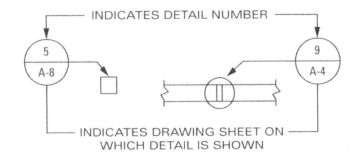

INDICATES DETAIL NUMBER

INDICATES DRAWING SHEET ON WHICH DETAIL IS SHOWN

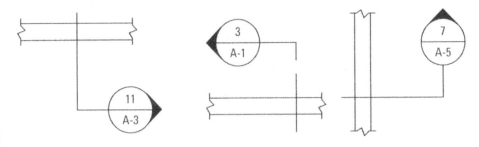

SECTION LINES AND SECTION REFERENCES

ARCHITECTURAL SYMBOLS

———— – —— – ———— DASH AND DOT

CENTER LINES, PROJECTIONS, EXT. ELEVATION LINES

—— –– –– –– –– –– –– —— DASH AND DOUBLE DOT LINE

PROPERTY LINES, BOUNDRY LINES

– – – – – – – – – – – – DOTTED LINE

HIDDEN, FUTURE OR EXISITING CONST. TO BE REMOVED

—————⌇————— BREAK LINE

TO BREAK OFF PARTS OF DRAWING

4'-0"	8" — SLASH
2'-8"	
8'-0½"	6¾" — ARROW
26'-8"	2" — DOT
5'-4"	½" — ACCENT

HORIZONTAL DIMENSION LINES

VERTICAL DIMENSION LINES

H.V.A.C. SYMBOLS

DUCT TRANSITIONS

RECTANGULAR DUCT SIZE
FIRST DIMENSION=SIDE SHOWN

SUPPLY DUCT UP & DOWN

SQUARE ELBOW WITH
TURNING VANES

DIFFUSERS OR REGISTERS
SUPPLY RETURN OR EXHAUST

FIRE PROTECTION SYMBOLS

 UPRIGHT HEADS

 PENDANT HEADS

 RECESSED HEADS

 FLUSH CONCEALED HEADS

 SIDEWALL HEADS

 FIRE PROTECTION PIPING

 STANDPIPE

 DRAINING PIPE

 DRY PIPE VALVE

RISER SYMBOLS

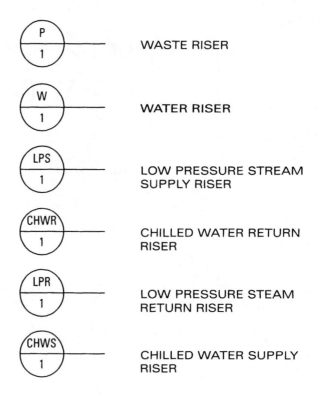

WASTE RISER

WATER RISER

LOW PRESSURE STREAM SUPPLY RISER

CHILLED WATER RETURN RISER

LOW PRESSURE STEAM RETURN RISER

CHILLED WATER SUPPLY RISER

PIPING FITTINGS, VALVES, & MISC. SYMBOLS

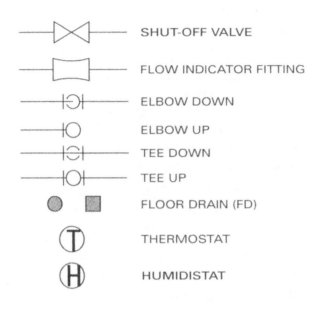

SHUT-OFF VALVE

FLOW INDICATOR FITTING

ELBOW DOWN

ELBOW UP

TEE DOWN

TEE UP

FLOOR DRAIN (FD)

THERMOSTAT

HUMIDISTAT

VARIABLE AIR VOLUME BOX

VARIABLE AIR VOLUME BOX
WITH REHEAT COIL

FAN POWERED VARIABLE AIR VOLUME
VOLUME BOX

FAN POWERED VARIABLE AIR VOLUME
VOLUME BOX

PIPING SYMBOLS

— – — COLD WATER (CW)

— – – — HOT WATER (HW)

— – – —140° HOT WATER (HW)

— – – – — RECIRCULATING HOT WATER TEMP INDICATED AS NEEDED (CHW)

—W— SOIL OR WASTE PIPE

—AW— ACID SOIL OR WASTE PIPE

— V — VENT PIPE

—RW— RAIN WATER PIPE

— F — FIRE PROTECTION

— G — FUEL GAS PIPING

———— UNDERGROUND PIPE IN TITLE

——▶— FLOW DIRECTION

— LPS — LOW PRESSURE STEAM

— LPR — LOW PRESSURE RETURN

— MPS — MEDIUM PRESSURE STEAM

— HPS — HIGH PRESSURE STEAM

– HWS-240 – 180 DEGREE HEATING WATER SUPPLY

– HWR-180 – 180 DEGREE HEATING WATER RETURN

– CHWS-30 – 30 DEGREE CHILLED WATER SUPPLY

– CHWR-30 – 30 DEGREE CHILLED WATER RETURN

— CHWS — CHILLED WATER SUPPLY

— CHWR — CHILLED WATER RETURN

Abbreviations Used in Mechanical Drawings

AFF	above finished floor	FPM	feet per minute
AFMCS	airflow measuring station	F&T	float and thermostatic trap
ALT	alternate		
AP	access panel	FT	foot or feet
ARCH	architect(ural)	FTG	footing
BHP	brake horse power	GA	gauge
BLDG	building	GAL	gallon
BSMT	basement	GALV	galvanized
BTU	British thermal unit	GC	general contractor
BWV	back water valve	GEN	generator
CFH	cubic foot per hour	GPH	gallon per hour
CI	cast iron	GPM	gallon per minute
CLG	ceiling	GR	grille
CO	clean out	HB	hose bibb (or faucet sill cock)
COMB	combination		
CONC	concrete	HP	horse power, high pressure
COND	condensate		
CONT	continuation, continue	HTG	heating
CONTR	contractor, contraction	HTR	heater
CORR	corridor	HVAC	heating ventilation/air conditioning
DEG	degree(s)		
DIA	diameter	ID	inside diameter
DIFF	diffuser	IN	inch, inches
DMPR	damper	INSUL	insulate(d), insulation
DN	down	INV	invert
DRWG	drawing	LBS/HR	pounds per hour
DTL	detail	LF	linear foot
EA	exhaust air	LVR	louver
ELEC	electric(al)	MAX	maximum
EMER	emergency	MBH	British thermal units/hour
EXH	exhaust		
EXIST	existing	MCH	mechanical
EXP JT	expansion joint	MEZZ	mezzanine
EXT	exterior	MMC	motor control center
F	Fahrenheit	MFR	manufacturer
FDV	fire department valve	MIN	minimum
FFE	finished floor elevation	MISC	miscellaneous
FL	floor	MVS	medical vacuum system
FLEX	flexible	NIC	not in contract

NO	number	
NTS	not to scale	
OA	outside air	
OD	outside dimension	
PD	pressure drop (feet of water)	
PLBG	plumbing	
PRES	pressure	
PSI	pounds per square inch	
PVC	polyvinyl chloride	
RA	return air	
RAD	radiator, radiation	
REG	register	
REQ'D	required	
RH	relative humidity	
RM	room	
RPM	revolutions per minute	
RWC	rainwater conductor	
SA	supply air	
SHT	sheet	
SP	stand pipe	
SP	static pressure (inches of water)	
SPECS	specifications	
SQ	square	
SS	stainless steel	
STRUC	structural	
TCP	temperature control line	
TEMP	temperature	
TYP	typical	
VAV	variable air volume	
VB	vacuum breaker	
VENT	ventilation, ventilator	
VIB ISOL	vibration isolator	
VOL	volume	
W	waste	
W/	with	
WH	wall hydrant	
W/O	without	

Equipment Abbreviations List

AC	air compressor
AD	air dryer
AF	air filter
AS	air separator
B	boiler
CC	cooling coil
CH	chiller
CT	cooling tower
CUH	cabinet unit heater
DC	dehumidification cooling coil
E	exhaust fan
EWH	electric water heater
FC	fan coil
FS	filter separator
GP	gas purification unit
GRV	gravity roof ventilator
H	humidifier
HC	heating coil
P	pump
PCC	cooling coil pump
PHC	heating coil pump
R	return fan
S	supply fan
SA	sound attenuator
SG	steam generator
SP	sump pump
T	diaphragm expansion tank
UH	unit heater
WWH	water to water heater

Symbols Used in Electrical Drawings

ELECTRICAL SYMBOLS

FLOOR	WALL	CEILING	
			DUPLEX 125v RECEPTACLE
			DOUBLE DUPLEX (QUAD) RECEPTACLE
			TELEPHONE OUTLET
			DATA SYSTEM OUTLET
			COMMUNICATION (voice and data)
			INTERCOM OUTLET
			FLOOR BOX
	H		HUMIDISTAT
	T		THERMOSTAT
		SD	SMOKE DECTECTOR
			DROP CORD WITH RECEPTACLES AS INDICATED
	J	J	JUNCTION BOX
	X	X	EXIT LIGHT
	C	C	CLOCK OUTLET
	S	S	CLOCK OUTLET
			MOTOR/EQUIPMENT (ceiling fan/exhaust fan)

APPENDIX 2: READING BLUEPRINTS, SPECIFICATIONS, AND SCHEDULES

ELECTRICAL SYMBOLS

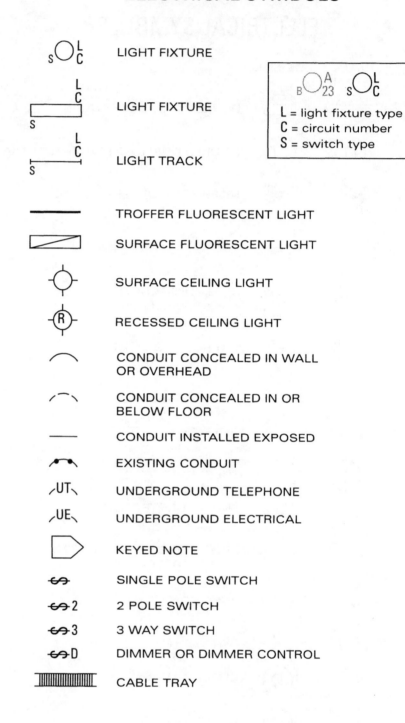

$_s\bigcirc {}^L_C$ LIGHT FIXTURE

LIGHT FIXTURE

LIGHT TRACK

L = light fixture type
C = circuit number
S = switch type

——— TROFFER FLUORESCENT LIGHT

SURFACE FLUORESCENT LIGHT

SURFACE CEILING LIGHT

RECESSED CEILING LIGHT

CONDUIT CONCEALED IN WALL
OR OVERHEAD

CONDUIT CONCEALED IN OR
BELOW FLOOR

CONDUIT INSTALLED EXPOSED

EXISTING CONDUIT

UNDERGROUND TELEPHONE

UNDERGROUND ELECTRICAL

KEYED NOTE

SINGLE POLE SWITCH

2 POLE SWITCH

3 WAY SWITCH

DIMMER OR DIMMER CONTROL

CABLE TRAY

ELECTRICAL SYMBOLS

WALL **CEILING**

| F | SMOKE DETECTOR (PHOTO ELECTRIC) |

| F |_{BT} BEAM TYPE SMOKE DETECTOR
(BT=BEAM TRANSMITTER, BR= BEAM RECEIVER)

| A | HEAT DETECTOR

—| H | MAGNETIC DOOR HOLDER

—| F | FIRE ALARM MANUAL STATION

—|CR| CODE/CARD READER

—| L | DOOR LOCK/STRIKE

Abbreviations Used in Electrical Drawings

A	ampere	DEPT	department
AC	above counter	DISC	disconnect
A/C	air conditioning	DIST	distribution
ADO	automatic door operator	DN	down
AFF	above finish floor	DPR	damper
AL	aluminum	DTL	detail
ALT	alternate	DWG	drawing
AMP	ampere	EC	electrical contractor
AMPL	amplifier	ELEC	electric(al)
ANNUN	annunciator	ELEV	elevator
APPROX	approximately	EM	emergency
AQUA	aquastat	EMT	electrical metallic tubing
ARCH	architect, architectural	EP	electric pneumatic
ATS	automatic transfer switch	EQUIP	equipment
AUTO	automatic	EWC	electric water cooler
AUX	auxiliary	EX	explosion proof
AV	audiovisual	EXH	exhaust
BATT	battery	EXIST	existing
BD	board	F	fuse
BLDG	building	FA	fire alarm
BMS	building management system	GAL	gallon
		GALV	galvanized
C	conduit	GC	general contractor
CAB	cabinet	GEN	generator
C/B	circuit breaker	GFI	ground fault circuit interrupter
CCTV	closed circuit television		
CKT	circuit	GFP	ground fault protector
CLG	ceiling	GND	ground
COMB	combination	HOA	hands-off-automatic switch
COMPR	compressor		
CONN	connection	HORIZ	horizontal
CONST	construction	HP	horsepower
CONT	continuous, continuation	HT	height
CONTR	contractor	HTG	heating
CONV	convector	HTR	heater
CRT	cathode-ray tube	HV	high voltage
C/T	current transformer	IC	interrupting capacity
CTR	center	IMC	intermediate metal conduit
CU	copper		

INCAND	incandescent	N/O	normally open
I/W	interlock with	OH	overhead
J-BOX	junction box	OL	overloads
KV	kilovolt	P	pole
KVA	kilovolt-ampere	PA	public address
KVAR	kilovolt-ampere reactive	PB	pull box
KW	kilowatt	PE	pneumatic electric
KWH	kilowatt hour	PF	power factor
LOC	locate, location	PH	phase
LT	light	PNL	panel
LTG	lighting	PP	power pole
LV	low voltage	PR	pair
MAG.S	magnetic starter	PRI	primary
MAX	maximum	PROJ	projection
MC	mechanical contractor	PRV	power roof ventilator
M/C	momentary contact	P/T	potential transformer
MC/B	main circuit breaker	PVC	polyvinyl chloride
MCC	motor control center	PWR	power
MDC	main distribution center	QUAN	quantity
MDP	main distribution panel	RECEPT	receptacle
MFR	manufacturer	REQD	required
MH	manhole	SEC	secondary
MIC	microphone	SHT	sheet
MIN	minimum	SIM	similar
MISC	miscellaneous	S/N	solid neutral
MLO	main lugs only	SP	spare
MMS	manual motor starter	SPECS	specifications
MOA	multiple outlet assembly	SPKR	speaker
MSP	motor starter panelboard	SS	safety disconnect switch,
MSWB	main switchboard		selector switch
MT	mount	STA	station
MT.C	empty conduit	STD	standard
MTR	motor(ized)	SW	switch
N.I.C.	not in contract	SWBD	switchboard
N.T.S.	not to scale	SWGR	switchgear
N/C	normally closed	SYM	symmetrical
NEC	national electrical code	SYS	system
NEMA	National Electrical Manu-	TEL	telephone
	facturer's Association	TERM	terminal
NFSS	non-fused safety discon-	TRANSF	transformer
	nect switch	T'STAT	thermostat

TV	television	VDT	video display terminal
TYP	typical	VDU	video display unit
UE	underground electrical	VERT	vertical
UG	underground	VOL	volume
UH	unit heater	W	watt
UT	underground telephone	W/	with
UV	unit ventilator	W/O	without
V	volt	WP	weatherproof
VA	volt amperes		

Specifications

Specifications are pages of detailed information regarding the technical requirements for every material and piece of equipment that goes on and into a building. Specifications are organized by type of material or piece of equipment and follow a standardized protocol not only for what they contain but also for how they are organized and numbered. Starting in 2004 the standardized list of specification divisions for commercial and institutional structures was expanded from sixteen to the following:

Procurement and Contracting Requirements Group
 Division 00 — Procurement and Contracting Requirements
Specifications Group
General Requirements Subgroup
 Division 01 — General Requirements
Facility Construction Subgroup
 Division 02 — Existing Conditions
 Division 03 — Concrete
 Division 04 — Masonry
 Division 05 — Metals
 Division 06 — Wood, Plastics, and Composites
 Division 07 — Thermal and Moisture Protection
 Division 08 — Openings
 Division 09 — Finishes
 Division 10 — Specialties
 Division 11 — Equipment
 Division 12 — Furnishings
 Division 13 — Special Construction
 Division 14 — Conveying Equipment
 Divisions 15–16 — *Reserved for Future Expansion*

Facility Services Subgroup

Division 20 — *Reserved for Future Expansion*

Division 21 — Fire Suppression

Division 22 — Plumbing

Division 23 — Heating Ventilating and Air Conditioning

Division 24 — *Reserved for Future Expansion*

Division 25 — Integrated Automation

Division 26 — Electrical

Division 27 — Communications

Division 28 — Electronic Safety and Security

Division 29 — *Reserved for Future Expansion*

Site and Infrastructure Subgroup

Division 30 — *Reserved for Future Expansion*

Division 31 — Earthwork

Division 32 — Exterior Improvements

Division 33 — Utilities

Division 34 — Transportation

Division 35 — Waterways and Marine Construction

Divisions 36–39 — *Reserved for Future Expansion*

Process Equipment Subgroup

Division 40 — Process Integration

Division 41 — Material Processing and Handling Equipment

Division 42 — Process Heating, Cooling, and Drying Equipment

Division 43 — Process Gas and Liquid Handling, Purification and Storage Equipment

Division 44 — Pollution Control Equipment

Division 45 — Industry-Specific Manufacturing Equipment

Divisions 46–47 — *Reserved for Future Expansion*

Division 48 — Electrical Power Generation

Division 49 — *Reserved for Future Expansion*

Each division is further subdivided into a numbered series of subdivisions specific to that division. The number of subdivisions will vary, tailored to the needs of a particular project. For example, Division 8, Openings, might contain subdivisions for:

- Hollow metal doors and frames
- Bronze doors and frames
- Wood doors
- Overhead doors
- Door hardware
- Glazing

Each subdivision will list not only the product name, brand, and model designation but also acceptable alternatives and specific requirements, such as accessories, standards for preparation, product handling, submittals, workmanship and installation, testing, appearance, quality assurance, environmental requirements if applicable, etc. Also listed are related sections in other divisions and in references such as the standards for the American Society for Testing and Materials (ASTM).

The following is an example of a specification for wood doors:

SECTION 08210
WOOD DOORS

Part 1 General

1.1 SUMMARY

A. Section Includes:
 1. Standard and fire rated type wood doors, with flush faces.
 2. Stile and rail type panel wood doors.
 3. Prefit and premachine wood doors.
 4. Wood doors in Artifact Areas shall be staved wood core construction.

B. Related Sections:
 1. Section 06101—Carpentry: Installation of wood doors.
 2. Section 08110—Hollow Metal Doors and Frames.
 3. Section 08710—Finish Hardware: Door hardware.
 4. Section 08800—Glazing: Glass and glazing for doors.
 5. Section 09900—Painting: Painting and finishing.
 6. Section 06220—Millwork.

1.2 REFERENCES

A. AWI Quality Standards of Architectural Woodwork Institute.
B. NFPA NO. 80 "Standards for Fire Doors."
C. ASTM E152—Methods for Fire Tests of Door Assemblies.

1.3 SUBMITTALS

A. Shop Drawings and Product Data: Submit in accordance with Section 01300. Indicate general construction, jointing methods, hardware and louver locations, and locations of cut-outs for glass.
B. Samples: Submit wood veneer samples for selection and acceptance.

1.4 QUALITY ASSURANCE

A. Fire-Rated Wood Doors: Provide wood doors which are identical in materials and construction to units tested in door and frame assemblies in accordance ASTM E152 and which are labeled and listed for ratings indicated by UL or other testing and inspection agency acceptable to authorities having jurisdiction.

1.5 PRODUCT HANDLING

A. Protect wood doors during transit, storage, and handling to prevent damage, soiling or deterioration.

1.6 GUARANTY/WARRANTY

A. Guarantee: Provide for replacing including cost of rehanging and refinishing, at no cost to Owner, wood doors exhibiting defects in materials or workmanship including warp and delamination within minimum period of 5 years from date of Substantial Completion of work.

Part 2 Products

2.1 ACCEPTABLE MANUFACTURERS

A. Type and Manufacturer: Architectural Grade, 5-ply hot pressed doors using Type 1 adhesive and AWI Premium Grade face veneers by Weyerhaeuser Company.

B. Other acceptable Manufacturers: Eggers Industries or Algoma Hardwoods.

2.2 DOORS

A. Flush Interior Doors: Solid core construction, except where hollow core is indicated, with White Oak (Birch in Artifact Areas) species face veneers; premium grade; face veneers: rift sliced sequence matched.

B. Stile and Rail Doors: White Oak (Birch in Artifact Areas) species construction with mortise and tenon or dowelled joints; premium grade.

C. Fire Rated Flush Doors: White Oak (Birch in Artifact Areas) species rift slice face veneers; premium grade. Refer to Drawings for UL label requirements.

D. Glass Stops: Stock wood door moldings. At fire-rated doors, provide metal glass stops as required.

2.3 FABRICATION

A. Fabricate wood doors in accordance with requirements of AWI Quality Standards.

B. Fabricate fire rated doors in accordance with requirements of Underwriters' Laboratories (UL), UL label on each door. Provide head and sill rails and lockblock.

C. Provide doors with minimum 1-¼ inch thick edge strips, of wood species to match face veneers except as required for UL rating.

D. Make cut-outs and provide stops for glass and louvers. Install metal door louvers. Seal cut-outs prior to installation of moldings.

E. Provide astragals for double doors (and dutch doors). Provide in accordance with UL requirements.

F. Bevel strike edge of single acting doors ⅛ inch to 2 inches. Radius strike edge of double acting swing doors 2-⅛ inches.

G. Prepare doors to receive hardware. Refer to Section 08710—Finish Hardware for hardware requirements. Prefit and bevel to net opening size less approximately ³⁄₁₆ inch in width and ⅜ inch in height for doors occurring over hard surface floors and ¾ inch in height for doors occurring over carpet, unless otherwise indicated on drawings. Slightly ease vertical edges.

Part 3 Execution

3.1 INSTALLATION

A. Installation of wood doors is specified under Section 06101, Carpentry.

Schedules

Schedules are lists, organized by room number, for a particular type of item or material. For example, a door schedule will list every room or space that has a door. The schedule contains the room number, the type of door, size, finish, etc., as shown on page 161.

A room finish schedule will list every room in the building and will show the specific type of flooring (e.g., sheet vinyl, carpet tile, concrete with sealer), wall finish (e.g., acrylic paint—satin finish, vinyl wall fabric), and ceiling material (e.g., 2'x2' recessed grid acoustic tile, veneer plaster, concrete) used in the project. Depending on the size of the project, schedules might be short enough to be listed on the plans or they may be many pages contained in books or binders.

As with drawings, the more carefully you review specifications and schedules, the fewer mistakes will be made, which in turn helps keep you on schedule and on budget, with a facility that functions as you envisioned.

Door Schedule

SHEET	DOOR	ROOM NAME	RM. #	WIDTH	HEIGHT	THICK	TYP	MATL	FINISH	TYP	MATL	FINISH
A2.44	464A	Office	B18	3-0	7-0	1-¾	A	WD	ST-1	1	HM	P
A2.42	466	Reference Classroom	B9	6-0	8-10 ¼	2-¼	F	BRZ	—	5	BRZ	—
A2.43	468	Public Lockers	B15	6-0	8-10 ¼	2-¼	F	BRZ2	—	5	BRZ	—
A2.43	485	Storage Photograph	B11	6-0	7-0	1-¾	A	WD	ST-1	1	HM	P
A2.43	488	Reading Room	B2-8	6-0	8-10 ¼	2-¼	F	BRZ	—	6	BRZ	
A2.52	500.1	Corridor		3-0	7-0	1-¾	A	HM	P	1	HM	P

An example of a door schedule.

Glossary

add-alternate An option or construction item added to a project after the bidding process when it becomes clear that contingency funds are available. *See also* deduct-alternate.

adjacencies Rooms or spaces that either share a common boundary or are in close proximity.

air handler A large fan that circulates air through ductwork; part of an HVAC system.

Americans with Disabilities Act (ADA) A federal law that prohibits discrimination and ensures equal opportunity for persons with disabilities. Among other things, the act governs access issues for entering, moving around, and using the facilities in a public building. (For more information, see http://www.ada.gov.)

archival Of or pertaining to an archive; of a quality suitable for long-term preservation of collections.

area of refuge A location in a building designed to hold occupants during a fire or other emergency when evacuation may not be safe or possible. Occupants can wait there until rescued.

as-built drawings The final set of drawings, produced at the conclusion of construction to show the departures that the builder made from the original construction documents.

building codes Regulations that specify construction parameters for safety, for zoning, and for livability; generally established by state or local governments. Also called regulatory codes.

building commissioning A process by which an independent specialist evaluates the performance of a completed construction project to ensure that it is functioning to design specifications.

building committee A committee appointed by the governing board of an organization to oversee a construction project.

certificate of occupancy A document that provides authorization from the local government for a building to be used; issued upon verification that the building is in full compliance with current building codes and is, therefore, safe for occupancy.

change order An amendment to a construction contract; often results from an oversight, the discovery of a mistake, or an idea for an improvement.

clear space The distance from the floor to the bottom of anything that hangs from the ceiling; space needed for safe transport of artifacts.

collection(s) Items and objects at the core of a museum's educational, research, and exhibition activities; generally treated as permanent and often divided between museum collections (usually three-dimensional objects) and archival collections (usually two-dimensional).

Color rendering index (CRI) A quantitative measure of the ability of a light source to reproduce colors faithfully in comparison with an ideal light source.

competitive bidding Solicitation of multiple (usually at least three) general construction proposals from qualified contractors.

conservator A professional devoted to the preservation of cultural property for the future. Conservators often specialize in particular kinds of collections or material, such as books and paper or textiles.

construction documents A set of drawings, plans, and specifications that contractors use to build a construction project. Also known as CDs.

construction manager A specialist responsible for achieving project objectives, including the management of quality, cost, time, and scope; oversees the installation of the materials and equipment specified in the construction documents.

contingency fund An amount (often a percentage of the total budget) in a construction budget set aside for unanticipated or unbudgeted expenses.

curator A person who manages or organizes a museum or archival collection.

deduct-alternate An option for reducing the cost of a project if bids come back higher than anticipated or to make up for an unexpected cost that arises during construction. *See also* add-alternate.

design-bid-build A system of contracting in which design plans and specifications are first prepared by an architect and then awarded through a competitive bid process to a contractor to complete the construction.

design-build A system of contracting in which a single entity performs both design and construction under a single contract.

design development The stage in a construction project that follows schematic design and in which the schematic design decisions are worked out in greater detail.

dew point The temperature at which moisture will condense from air.

dust spot efficiency A measure of the ability of a filter to remove dust from the air.

endowment A permanent investment account maintained by a nonprofit organization with the goals of capital appreciation (growth of principal) and income. Income is traditionally used to meet the current expenses of operation.

facility program A planning document with detailed information about each of the spaces needed for the programs and services in a building project.

feasibility study A formal assessment of the probability that an organization can reach a specific financial goal in a capital campaign; often conducted by an outside consultant who interviews potential donors and community leaders.

final completion The acceptance of and conclusion of a building project through a signed document.

final inspection An inspection of the building conducted prior to signing off on final completion. Also called final walk through.

humidity A measure of the amount of moisture in the air. *See also* relative humidity.

HVAC An acronym for a heating, ventilation, and air-conditioning.

infrared light The part of the electromagnetic spectrum that produces heat.

LED An acronym for light emitting diode.

LEED An acronym for Leadership in Energy and Environmental Design, an organization that certifies "green" construction projects for following sustainability standards.

lux A unit of illumination equal to 1 lumen per square meter; used to calculate the amount of light to which an object is exposed: 10 lux equals the amount of light produced by 1 candle at a distance of 1 foot (therefore 10 lux = 1 foot-candle).

lux hour A measure of light exposure (illuminance in units of lux multiplied by length of exposure in hours).

MERV (minimum efficiency reporting value) A system that rates the efficiency of particulate filters that are part of an HVAC system.

newspaper of record A term that may refer either to any publicly available newspaper that has been authorized by a government to publish public or legal notices, or any major newspaper that has a large circulation and whose editorial and news-gathering functions are considered professional and authoritative.

object An artifact, generally three dimensional, in the collection of a museum.

off-gassing The process by which volatile chemicals evaporate and release chemicals into the air. Materials such as paints, stains, varnishes, carpet, insulation, flooring, cabinets and countertops, plywood, particleboard, and paint strippers can produce significant off-gassing and affect artifacts and people.

operating cost A recurring expense related to the operation of an organization.

OSHA An acronym for the Occupational Safety and Health Administration, a federal agency. OSHA requirements for workplace safety and health apply to

museums and historical organizations. For example, OSHA compliance specifies how chemicals and flammables are stored.

prefinal inspection An inspection conducted by the owner and architect at the request of the contractor when the contractor believes the project has reached substantial completion. Also known as a walk through or preliminary inspection.

Preservation Index A calculation that predicts the useful life of artifacts in units of years based on temperature and humidity at a specific point in time.

preservation metric A general term for calculations that characterize the quality of an environment as it relates to the preservation of museum and library collections.

project manager *See* construction manager.

punch list List detailing items to be fixed by the contractor prior to final payment at the conclusion of the project.

regulatory codes *See* building codes.

rehabilitation Construction that emphasizes the retention and repair of historic materials when preparing a property for efficient contemporary use.

relative humidity (RH) Ratio of the amount of water vapor in the air at a given temperature to the maximum amount it could hold at that temperature. Relative humidity is expressed as a percentage.

release from mechanic's lien A legal document from the builder releasing the owner from liability for disputes between the general contractor and vendors or subcontractors.

renovation *See* rehabilitation.

restoration Construction work that focuses on the retention of materials from the most significant time in a property's history while permitting the removal of materials from other periods.

reuse The process of adapting historic buildings for new uses without seriously damaging their historic character.

schematic design The phase in the design of a project in which an architect prepares schematic diagrams giving a general view of the components and the scale of the project. Schematic design involves extensive and detailed discussions with and input from the client.

set point The temperature and humidity that you require the HVAC system to achieve.

specifications A set of documents listing the precise details of each material and piece of equipment in a building project. Specifications are included in construction documents and are used to bid a project.

substantial completion The date at which a building project is sufficiently

complete, in accordance with the construction contract documents, so that the owner may use or occupy the building for its intended use.

ultraviolet light (UV) Radiation in the electromagnetic spectrum invisible to the human eye that can damage certain museum collections.

value engineering A term used to describe the process either of reducing quality or quantity or of eliminating something from the construction budget in order to reduce cost.

vapor barrier A material that retards the movement of water vapor through walls, floors, and ceilings.

variable air volume unit (VAV) A piece of equipment that adjusts the quantity, temperature, and humidity of air at the point of delivery to a space.

visible light The part of the electromagnetic spectrum that can be detected by the human eye.

volatile organic compounds (VOCs) A class of potentially harmful gasses emitted primarily by new products and newly applied materials. Examples include paints and other finishes, paint strippers, cleaning supplies, pesticides, building materials and furnishings (particularly carpeting), graphics and craft materials including glues and adhesives.

walk through *See* prefinal inspection.

Further Reading

General Museum Construction

Most of the books available on museum construction were written with larger organizations in mind. Of those books, the following include some useful information for smaller organizations.

Crimm, Walter L., Martha Morris, and L. Carole Wharton. *Planning Successful Museum Building Projects*. Lanham, MD: AltaMira Press, 2009. Chapters that may be particularly useful to smaller museums are "Financial Planning and Cost Management" and "The Capital Campaign."

Lord, Gail Dexter, and Barry Lord, eds. *The Manual of Museum Planning*. 2nd ed. Lanham, MD: AltaMira Press, 1999. This comprehensive book covers all aspects of museum planning and has a global focus.

Pacifico, Michele F., and Thomas P. Wilsted, eds. *Archival and Special Collections Facilities: Guidelines for Archivists, Librarians, Architects, and Engineers*. Chicago: Society of American Archivists, 2009. This book is described as a "companion piece" to Wilsted's 2007 book (listed below). Any organization will find the guidelines for fire protection, security, lighting, materials and finishes, storage equipment, and functional spaces useful.

Wilsted, Thomas P. *Planning New and Remodeled Archival Facilities*. Chicago: Society of American Archivists, 2007. The focus of this book, as the title states, is on archival facilities. Although most of its examples are of larger facilities, it contains information that is useful to midsize and smaller organizations. It clearly describes the development of a facility program (called a *building program* in this book). There are also chapters on moving collections and building maintenance.

Audience

Diamond, Judy, Jessica J. Luke, and David H. Uttal. *Practical Evaluation Guide: Tools for Museums and Other Informal Educational Settings*. 2nd ed. Lanham, MD: AltaMira Press, 2000. A user-friendly book about how to evaluate the effectiveness of museum exhibits and programs.

Falk, John H., and Lynn D. Dierking. *Learning from Museums: Visitor Experiences and the Making of Meaning.* Lanham, MD: AltaMira Press, 2000. Both practical and theoretical, this book explores how people learn during museum visits and presents ideas for how museums can improve the visitor experience.

Mattson, Jim, and Erik Holland. "Checking Your Pulse: How to Track and Apply User Statistics." Minnesota Historical Society *Tech Talk*, 2009. How to collect and use statistics to evaluate strategic plans and program performance. http://www.mnhs.org/about/publications/docs_pdfs/CheckingPulse.pdf.

Construction Management

"How to Select a Construction Manager," a resource from the Construction Management Association of America (CMAA). http://cmaanet.org/selecting-a-cm.

"Museum Facility Specifications," a 1999 National Park Service Conserve O Gram with lists of sources to consult when outlining requirements and specifications for museums and archival facilities. http://www.nps.gov/history/museum/publications/conserveogram/20-01.pdf.

Environmental Controls

Appelbaum, Barbara. *A Guide to Environmental Protection of Collections.* Madison, CT: Sound View Press, 1991.

Cassar, May. *Environmental Management. A Guide for Museums and Galleries.* New York and London: Routledge, 1995; digital edition, 2005.

Ellis, Rebecca. "Getting Function from Design: Making Systems Work." Northeast Document Conservation Center, *Preservation Leaflets*, 2007. The author addresses the installation, testing, tuning, and monitoring of museum HVAC systems. http://www.nedcc.org/resources/leaflets/2The_Environment/03FunctionFromDesign.php.

Lull, William P., with Paul N. Banks. *Conservation Environment Guidelines for Libraries and Archives.* Ottawa: Canadian Council of Archives, 1995.

Sebor, Andrew J. "Heating, Ventilation, and Air-Conditioning Systems." Pp. 135–46 in Carolyn Rose and Amparo de Torres, eds. *Storage of Natural History Collections: A Preventative Conservation Approach.* Iowa City, IA: Society for the Preservation of Natural History Collections, 1996.

Fundraising

Bassoff, Michel, and Steve Chandler. *Relation Shift: Revolutionary Fundraising.* San Francisco, CA: Robert D. Reed Publishers, 2001. This book makes the case that successful fundraising is a matter of attitude. It lists "Fundraising's 20 Most Damaging Myths" and counters each of them with practical advice.

Bray, Ilona, J.D. *Effective Fundraising for Non-profits: Real-World Strategies that Work.* Berkley, CA: Nolo, 2005. Although it does not specifically address capital campaigns, this well-written and comprehensive book is very useful because it focuses on smaller nonprofit organizations.

Brophy, Sarah S. *Is Your Museum Grant-Ready? Assessing Your Organization's Potential for Funding.* Lanham, MD: AltaMira Press, 2005. A helpful book that will aid novice fundraisers as they prepare to submit grant applications.

Cilella, Salvatore G., Jr. *Fundraising for Small Museums: In Good Times and Bad.* Lanham, MD: AltaMira Press, 2011. The author treats fundraising comprehensively and includes practical tips as well as theory. His chapter on capital campaigns is particularly useful. Although most of the case studies and examples are not of organizations located in small communities, this useful book will help people with little or no fundraising experience as well as those already familiar with the topic.

The Fieldstone Alliance's "Revenue Evaluation Matrix" is "a tool for evaluating an organization's financial situation and revenue mix." http://www.fieldstonealliance. org/client/articles/Tool-Revenue_Evaluation_Matrix.cfm.

Hopkins, Karen Brooks, and Carolyn Stolper. *Successful Fundraising for Arts and Cultural Organizations.* 2nd ed. Phoenix, AZ: The Oryx Press, 1997. This comprehensive book focuses on arts and cultural organizations. It addresses the needs of smaller organizations as well as larger ones. Chapter 9 deals with capital and endowment campaigns.

Lighting

Herskovitz, Bob, and Rich Rummel. "Track Lighting in Museums: Part 1: Selection and Design." Minnesota Historical Society *Tech Talk,* 2006. Explains how track lighting for museums differs from use in other settings. http://www.mnhs. org/about/publications/techtalk/TechTalkNovember2006.pdf.

Herskovitz, Bob, and Rich Rummel. "Track Lighting in Museums: Part 2: Lighting and Control." Minnesota Historical Society *Tech Talk,* 2007. Provides information for cost-effective strategies to control light and minimize damage

to museum collections. http://www.mnhs.org/about/publications/techtalk/TechTalkJanuary2007.pdf.

Illuminating Engineering Society of North America. "RP-30-96 Museum and Art Gallery Lighting: A Recommended Practice." 1996. This article has been in the process of revision for several years. While a bit dated, it is still a useful reference.

Lull, William P., and Linda E. Merk. "Lighting for Storage of Museum Collections: Developing a System for Safekeeping of Light-Sensitive Materials." *Technology & Conservation* 7.2 (1982): 20–25.

Museum Exhibits

McKay, Tom. "Exhibiting Local Heritage." A series of nine articles from the Wisconsin Historical Society's newsletter *Exchange* that address planning the content of local history exhibits, examine basic exhibit design principles, and present inexpensive techniques for exhibit construction. http://www.mnhs.org/exhibitplan.

Oda, James C. "Planning and Creating Effective Exhibits on a Limited Budget: Part I." Ohio Historical Society, Local History Notebook, July/August 1994. A good introduction to exhibits, particularly helpful to all-volunteer organizations. http://www.ohiohistory.org/resource/oahsm/notebook/julaug1994.html.

Oda, James C. "Planning and Creating Effective Exhibits on a Limited Budget: Part II." Ohio Historical Society, Local History Notebook, September/October 1994. Explains basic construction techniques. http://www.ohiohistory.org/resource/oahsm/notebook/sepoct1994.html.

Schuck, Raymond F. "Exhibit Planning in the Small Historical Society." Ohio Historical Society, Local History Notebook, September/October 1985. Although outdated for exhibit lighting, this is still a useful basic reference. http://www.ohiohistory.org/resource/oahsm/notebook/sepoct1985.html.

Museum Standards

StEPs (Standards and Excellence Program for history organizations) is a voluntary assessment program created by the American Association for State and Local History and is intended for small and midsized history organizations. Organizations that enroll in the self-paced, self-study program use assessment questions and performance indicators (Basic, Good, Better) to rate their policies and practices in six standards sections. Participating organizations can identify

their strengths and areas needing improvement and then begin taking steps to plan for change. http://www.aaslh.org/steps.htm.

Planning

"Building Buildings: The Facility Development Process for Nonprofits." An online resource from the Whelan Group with a list of fourteen crucial decision points that an organization will face during planning and construction of a facility. http://www.whelangroup.com/files/the_facility_development_for_nonprofits.pdf.

"Determining Museum Space Storage Requirements," a 1997 National Park Service Conserve O Gram that offers various scenarios for planning museum collection storage space. http://www.nps.gov/history/museum/publications/conserveogram/04-11.pdf.

"Facility Projects: Before You Begin," a three-part article by the Nonprofit Finance Fund that discusses issues to consider before undertaking a facility project. http://nonprofitfinancefund.org/nonprofit-consulting/planning-guides.

George, Gerald (and Cindy Sherrell-Leo). *Starting Right: A Basic Guide to Museum Planning.* 2nd ed. Nashville, TN: American Association for State and Local History, 2004. Basic advice on forming a museum as well as topics such as choosing a building, caring for collections, creating exhibitions, and fund raising.

Lord, Barry. "Is It Time to Call in an Architect? Perhaps Not Yet." *International Journal of Arts Management* 7.1 (fall 2004). A useful article that stresses the need for in-house planning before an architect is selected. http://www.lord.ca/Media/Artcl_timetocallanarchitect_barry.pdf.

The Museum Assessment Program (MAP) is a program of the American Association of Museums. It provides resources for a museum to conduct a self-study and a visit by a peer reviewer who subsequently provides an objective report with recommendations for organizational improvement. http://www.aam-us.org/museumresources/map/index.cfm.

Safeguarding Collections

Brown, Karen E. "Preservation Concerns in Building Design: Select Bibliography." Most of the titles in this Preservation Leaflet from the Northeast Document Conservation Center date from the 1990s. http://www.nedcc.org/resources/leaflets/1Planning_and_Prioritizing/08PreservationConcerns.php.

Motylewski, Karen. "Protecting Collections During Renovation." A good discussion of the risks to collections during a renovation project. http://www.nedcc.org/resources/leaflets/3Emergency_Management/09ProtectingCollections.php.

Security

Adams-Graf, Diane, and Claudia J. Nicholson, "Thinking Ahead about Museum Protection: An Ounce of Prevention Is Worth a Pound of Cure." Minnesota Historical Society *Tech Talk*, 2000. Basic planning for security. http://www.mnhs.org/about/publications/techtalk/TechTalkMarch2000.pdf.

Layne, Stevan P. "Closing the Barn Door: Dealing with Security Issues." Technical Leaflet #219. Nashville, TN: American Association for State and Local History, 2002. This leaflet, included in *History News* 57.4 (autumn 2002), is a basic introduction to security issues.

Layne, Stevan P. "An Ounce of Prevention—Worth MORE Than a Pound." Technical Leaflet #253. Nashville, TN: American Association for State and Local History, 2011. This leaflet, included in *History News* 66.1 (winter 2011), builds on and updates Layne's 2002 publication and includes a good list of additional resources.

National Fire Protections Association. *NFPA 909. Standard for the Protections of Cultural Resources, Including Museums, Libraries, Places of Worship and Historic Properties.* Quincy, MA: National Fire Protection Association, 2010.

National Fire Protections Association. *NFPA 914. Recommended Practice for Fire Protection in Historic Structures.* Quincy, MA: National Fire Protection Association, 2010.

"Suggested Practices for Museum Security as Adopted by the Museum, Library and Cultural Properties Council of ASIS International and the Museum Association Security Committee of the American Association of Museums." June 2008. http://www.asisonline.org/councils/documents/SuggestedPracticesforMuseumSecurity.pdf.

Index

abbreviations, in construction drawings, 149–50, 154–56

accessibility: security and, 100; for visitors with disabilities, 19, 52, 53

ADA (Americans with Disabilities Act), 19, 52, 53

add-alternates, 42–43, 117

adjacencies, 26, 29, 34, 37, 57, 61

adjustment to new surroundings, 128–29

air conditioning. *See* HVAC system(s)

air filtration, 70, 80–84. *See also* HVAC system(s)

air handler and chiller systems, 73, 76

alternates, 42–43, 117

alternative energy, 75–78

American Society of Heating, Refrigerating and Air-Conditioning Engineers (ASHRAE), 81–82

Americans with Disabilities Act (ADA), 19, 52, 53

appearance, of building, 11

architect. *See* designer

architectural design, 20–23, 49, 84–86, 100. *See also* design development; schematic design

archives, 12–13, 32, 56–57

area of refuge, 101

artifacts, preservation of: collections storage and, 14; environmental control and, 69, 70, 78–81, 117; fire suppression systems and, 96–99; light and, 87–96; off-gassing pollution and, 107; theft prevention and, 101–2

as-built drawings, 124

ASHRAE (American Society of Heating, Refrigerating and Air-Conditioning Engineers), 81–82

barriers, 100

bid process, 111–13

blueprints, 133–34

board of directors, 5, 6–7

boilers, 73, 76

bubble diagram, 38–39

budget management, 115–17. *See also* finances

building commissioning, 127

building committee, 5–7, 27, 39, 41, 49, 50, 111, 115, 116

building maintenance, 37, 66

building(s): appearance of, 11; determining type of, 17; form and function of, 23; methods for designing and constructing, 21; renovation of, 19

cameras, security, 100, 102–3

ceiling clearance, 61

change orders, 43, 116

chemicals, 82–83, 103–4, 107, 122

classroom, 33, 60

clearance space, 61

climate control. *See* HVAC system(s)

coatroom, 30, 54

code compliance, 19, 50–51, 109–11

collections storage, 12–15, 34, 61–63

community, considerations for, 10, 11–12, 18

community room, 33–34, 60

constant volume systems, 73

construction: architectural, electrical, and mechanical installation, 119–22; costs associated with, 42; new construction, 17; site preparation, 117–18; structural work, 118–19; substantial completion, 122–23

construction documents and drawings. *See* documents; drawings

construction management, 43, 115–17, 121

consultants: costs associated with, 43–44; for facility program, 25–26; for final review of construction documents, 111; for financial feasibility studies, 15–16; finding, 44

contingency fund, 42–43, 116

contractor's lien, 123

costs: hidden costs, 46–47; operating costs, 15, 16, 45–46, 47, 80; project costs, 40, 41–47. *See also* finances

daylight, 54, 85, 91, 92

deaccessioning, 15, 126

decision making, 6–7

deduct-alternates, 117

dehumidification, 70, 79–80. *See also* humidity control

deliveries, 36–37, 65

design-bid-build, 21

design-build, 21

design competition, 22

design development: and choosing materials, 103–7; drawings and, 49–50; fire suppression and, 96–99; HVAC system and, 69–86; issues for museums, 67; key to successful, 49; lighting and, 87–96; overview of, 49; for programmatic spaces, 56–60; for public spaces, 51–56; and regulatory codes, 50–51; security considerations and, 99–103; for support spaces, 61–67. *See also* project development; schematic design

designer: costs associated with, 41–42; and design firms, 23; finding, 21–22; of HVAC system, 77; questions for prospective, 22; selecting, 20–21; when to begin working with, 21

design firms, 23

detail drawings, 109, 138

Dew Point Calculator, 79

documents, 109–11, 124, 133–34

drawings, 49–50, 124, 134–39. *See also* abbreviations, in construction drawings; symbols, in construction drawings

dry pipe fire suppression system, 96, 97

dual-action fire suppression system, 97, 98

dust, 81–82, 83. *See also* air filtration

eating area, 30–31, 55

educational programs, 13

electrical installation, 119–22

elevation drawings, 110, 136

elevators, 38, 67

endowment, 46

energy: alternative energy, 75–78; energy efficiency, 46

engineering design, 49

entrance(s), 29, 51, 85

environment. *See* environmental issues; museum environment

environmental issues, 20

equipment, 32, 53, 55, 60, 61, 64; costs associated with, 45; manuals for, 124

exhibit construction workshop, 36

exhibits: assessing needs of, 12; gallery, 32–33, 57–59; lighting, 91–93

existing structure, 17

exterior lighting, 94

exterior security cameras, 100

facility program, 24–26, 28

fan coil units, 73, 76

fiberoptic lights, 94–95

Illustration Credits

CPSIA information can be obtained
at www.ICGtesting.com
Printed in the USA
LVHW102037041218
599237LV00015B/431/P